Voices of Ameri

Italians
in Chicago

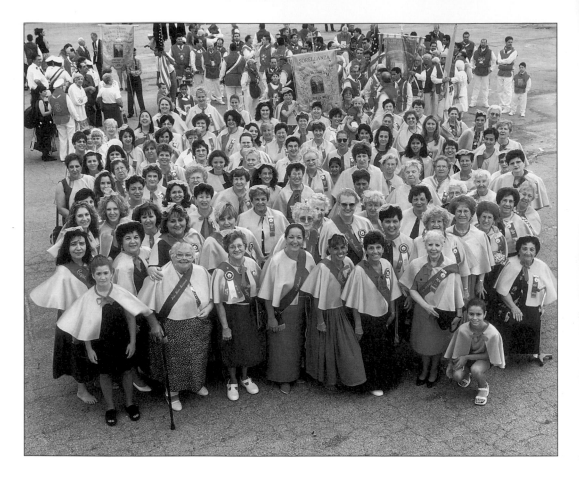

The Lauretana Sisterhood "Sorellanza" in 2000 carry on the tradition started by immigrant Altavillesi on Chicago's Near North Side.

Voices of America

Italians in Chicago

Compiled by
Dominic Candeloro

ARCADIA

Published by Arcadia Publishing,
an imprint of Tempus Publishing, Inc.
3047 N. Lincoln Ave., Suite 410
Chicago, IL 60657

Printed in Great Britain.

Library of Congress Catalog Card Number: 2001091398

For all general information contact Arcadia Publishing at:
Telephone 843-853-2070
Fax 843-853-0044
E-Mail sales@arcadiapublishing.com

For customer service and orders:
Toll-Free 1-888-313-2665

Visit us on the internet at http://www.arcadiapublishing.com

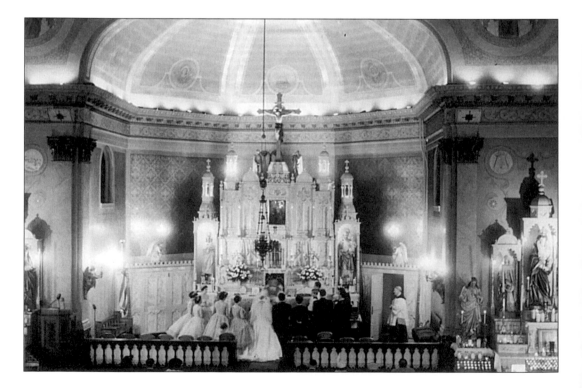

October 21, 1956 wedding of August DeLisi and Rose Camarda was concelebrated by Fr. Luigiambastiani and Fr. Francis Moreci, an uncle of the bride at St. Phillip.

CONTENTS

PREFACE

Glimpses and Echoes
Some Oral Histories of Chicago's Italians

This book is a collaborative, cumulative effort. Bits and pieces grew out of a quarter-century of my many activities in Italian American Studies. Professor Rudolph Vecoli introduced me to the field in 1966, at the University of Illinois, and his dissertation and articles are the major sources for information on Italians in Chicago before 1920.

Some of the interviews in this book came from the Italians in Chicago Oral History Project 1979–82, funded by the National Endowment for the Humanities at the University of Illinois, Chicago. The interviewers were young volunteers in the project. Interviews in this book also originated as pieces on the "Ciao, South Suburbia" radio show, which I did for 15 years on WCGO in Chicago Heights with Rose Ann Rabiola Miele, Anthony Scariano, and Angelo Ciambrone. The Clemente interview was part of an unrealized video production that Rose Ann Rabiola and I organized as part of the Italians in Chicago Project.

Oral history offers us echoes from the past. This book is incomplete. All history is incomplete. The choice of the subjects interviewed was random. There are too many males in this collection, and much is left out. Sometimes I found myself being too faithful to the original words of the narrator, and sometimes I think I edited the narrator too much. Oral history is what it is—the authentic raw material of history—echoes and glimpses of vignettes remembered by the humble and the great.

While I tried to maintain the presentation style of each narrator, to create readable text, I sometimes did heavy editing and condensation. To clarify omitted subjects, I used parenthesis. To insert a question or topic not spoken by the narrator, I used brackets. Interviewees are always unsettled by the way that the spoken word transcribes to the written word. The full text and tapes of all interviews are on file at the Italian Cultural Center at 1621 N. 39th Avenue, Stone Park, Illinois, 60165.

This book gives glimpses and echoes of what occurred in the Italian American past in Chicago. It is drenched in subjectivity <u>and</u> authenticity. This is what some people said about their lives, and here are some pictures. It's echoes and glimpses. Yet, I hope the readers will profit from the rich detail and humanity of these stories, and that they will see themselves and their families in history and develop a *"buon apetito"* for additional

authentic information on the subject.

All of the following institutions may be useful in locating additional information: Information History Research Center at the University of Minnesota, the Center for Migration Studies, The *Fra Noi*, The Italian Cultural Center, The American Italian Historical Association (http://www.mobilito.com/aiha), the H-ItAm Listserv, ItalianAncestry.com, FIERI, The Joint Civic Committee of Italian Americans, and the National Italian American Foundation. Also see the *Italian American Encyclopedia* published by Garland, the works of Humbert Nelli, Tina DeRosa, Peter Venturelli, Gloria Nardini, and myself on Italians in Chicago. My web site at http://www.ecnet.net/users/gcandel/home.html includes several essays on Italians in the Chicago area.

I have a long thank-you list. First there are the interview subjects themselves: Gloria Bacci, Edward Baldacci, Joe Bruno, Joe Camarda, Egidio Clemente, Joseph Farruggia, Albert LaMorticella, Father Armando Pierini, Anthony Scariano, and Maria Valiani. All but Bruno, Camarda, Farruggia, and Scariano have passed on.

The Italians in Chicago interviewers, Anthony Mansueto (Valiani, Baldacci) and Mary Piraino (Bacci) helped shape this book. Lisa Bacci helped edit the Gloria Bacci interview, and the late Ann Sorrentino transcribed and edited the Valiani interview. Paul Basile gave me full access to *Fra Noi* photo archives. Patricia Bakunas at the UIC Special Collections helped obtain the Clemente tapes and several photos used in the book from the University of Illinois, the University LIbrary Department of Special Collections, Italian American Collection. These photos are identified in the captions "UIC IA" and a reference number. I owe a debt of gratitude to the late Mary Ellen Batinick for directing the oral history segment of the Italians in Chicago Project. Heather Muir of the Immigration History Research Center helped me obtain the photo of the Casa del Popolo, and Mary Estes LaMorticella, Robert Clemente, and Aldo Valiani provided family photos. Gianna Sommi Panofsky shared the research she did with the late Eugene Miller on Chicago Italian Socialists.

I had excellent typing help from Angeline Sienko, Claudia Ruiz, Kris Kurth, and Jennifer Duffey. My wife, Carol, helped a great deal with text and photo editing. Karen and Steve Modzelewski, Anne Candeloro Klos, and Gina Candeloro De Butch helped with proofreading. Please contact me at D-Candeloro@govst.edu with your comments, corrections, and inquiries.

This book is dedicated to the memory of my sister, Rosemarie Candeloro Hawrysio, who was my biggest fan and who could tell quite a story herself. I only wish that I could have done a formal interview with her before her untimely death in February 2001.

Dominic Candeloro
Chicago Heights, Illinois
May 2001

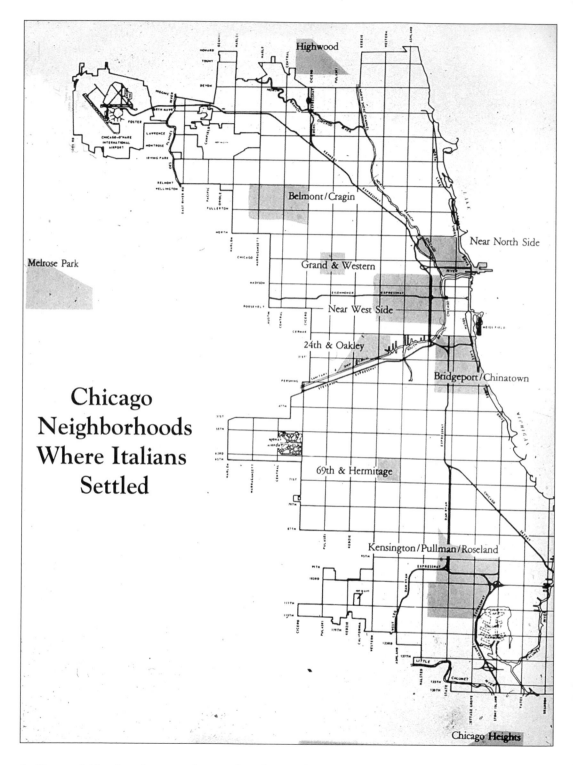

Highwood

Belmont / Cragin

Near North Side

Melrose Park

Grand & Western

Near West Side

24th & Oakley

Bridgeport / Chinatown

Chicago
Neighborhoods
Where Italians
Settled

69th & Hermitage

Kensington / Pullman / Roseland

Chicago Heights

Italian neighborhoods were clustered to the north, south, and west of the Loop. The coming of expressways and other expansion after World War II brought about their virtual demise.

• *The original Genoese/Lucchese neighborhood in the shadow of today's Merchandise Mart produced the first Italian Catholic Church of the Assumption in 1880.*

• *Toward the south end of the Loop, near the Polk Street Station, the Riciglianeso (Salerno) lived. Over the years, the colony moved south into what is now known as Chinatown, where the Sicilians from Nicosia joined them. The Scalabrinian church of Santa Maria Incoronata (patroness of Ricigliano) remained the focal center for the community until the 1980s, when it became the Chinese mission of St. Therese.*

• *On the Near Northwest Side, in a neighborhood made famous by Jane Addams and Hull House, the largest Italian colony grew up. This Taylor Street area contained about one-third of the city's Italians—a mixture of people from Naples, Salerno, Basilicata, the Marche, and Lucca. The neighborhood was also shared with Russian Jews to the south and Greeks to the north. For the most part, this area could be considered a slum in the pre-1920 era. The Scalabrinian Churches of the Holy Guardian Angel and Our Lady of Pompeii and a hospital founded by Mother Cabrini served the zone.*

• *On the Near Northwest Side, a varied community of Baresi, Sicilians, and others grew up around the Santa Maria Addolorata Church.*

• *Perhaps the most colorful Italian sector was in the 22nd Ward on the city's Near North Side. Known alternately as "Little Sicily" and "Little Hell," this neighborhood was home to some 20,000 by 1920. Most originated from the small towns surrounding Palermo, like Altavilla Milicia. The Servite Church of St. Philip Benizi provided the backdrop for a score of feste each summer sponsored by paesani-based mutual benefit societies such as the Maria Santissima Lauretana Society. In addition to the major inner city Italian enclaves, a number of outlying and suburban colonies formed in the pre-1920 period.*

• *A settlement of Toscani who worked at the McCormick Reaper plant appeared in the 1890s, a few miles to the southwest of the Loop at 24th and Oakley.*

• *Also to the south in the famous planned company town established by George Pullman, there was a colony of Italian brickmakers from Altopiano Asiago. The nearby Roseland neighborhood was also home to a contingent of Piedmontese and Sicilians.*

• *Railroad laborers from Rippacandida (Basilicata) heavily settled the town of Blue Island, at the southwest border of the city.*

• *Chicago Heights, 30 miles to the south of the Loop, had a population that was 50% Italian by 1920, most hailing from San Benedetto del Tronto (Marche), Caccamo (Sicily), Amaseno (Lazio), and Castel di Sangro (Abruzzo).*

• *Melrose Park, 16 miles to the west of the central city, was a place of settlement attracting Italians from the inner city to the wide-open spaces of the suburbs. The establishment of the major religious feast of Our Lady of Mount Carmel eventually identified the town as the quintessential Chicago Italian suburb.*

• *After the turn of the century, migrants from Modenese towns formed the Highwood Italian community, 28 miles north of the city.*

INTRODUCTION

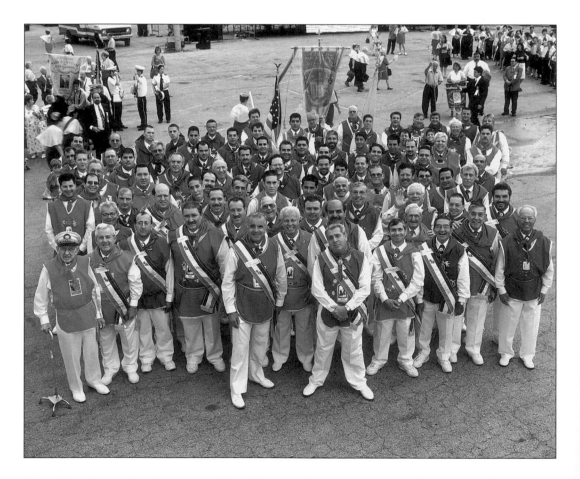

Proud Members of the Lauretana Fratellanza—September 2000 at the Cermak Plaza site.

A Sketch of Italian-American History in Chicago

Italians have been in Chicago since the 1850s. Up to 1880, the community consisted of a handful of enterprising Genoese fruit sellers, restaurateurs, and merchants, with a sprinkling of plaster workers. Most Chicago Italians, however, trace their ancestry back to the wave of unskilled southern immigrants who came to the United States between 1880 and 1914. As a rail center, an industrial center, and America's fastest growing major city, Chicago offered opportunities for immigrants from all nations. In the nineteenth century, it was Mecca for German and Irish migration. In

Giuseppe Bertelli was the founder of La Parola del Popolo *in 1908. Giana Panofsky and Eugene Miller have painstakingly researched the personalities and the issues among Chicago's Italian Socialists in their unpublished "Struggling in Chicago."*

the early twentieth century, Italians, Russian Jews, and, most importantly, Poles found a place in Chicago. Later, blacks from America's South, Mexican, and Asian immigrants added their presence to the city, making it home today to sizable colonies of over 80 different nationalities. Chicago's black population is second only to that of New York City; at one time or another it has been the largest Lithuanian city, the second largest Bohemian city, the second largest Ukrainian city, and the third largest Swedish, Irish, Polish, and Jewish city in the world!

As in many older American cities, ethnic identities have persisted well "beyond the melting pot," and a sophisticated understanding of the economic, social, political, and cultural dynamics of the city is impossible without careful consideration of ethnic factors. Being part of the complex interaction and being consistently outnumbered by Irish, Poles, African-Americans, and Hispanics, Italian aspirations for power and prestige have often been thwarted.

Typical chain migration patterns prevailed, with families and villages gradually reforming in Chicago neighborhoods as workers accumulated savings to send for their relatives. Throughout the early twentieth century, there continued to be a good deal of residential mobility among the Italians. Nevertheless, their major colonies, as first enumerated by Rudolph Vecoli, were shaped as follows (opposite):

Mostly *contadini* from dozens of towns in Italy, both North and South, settled around the core of the central city and in selected suburbs. They practiced *campanilismo*, living near others from the same village or region. The core colonies were considered slums, their inhabitants the object of intensive efforts by social workers (to make them middle class), and masterful maneuvers by political ward bosses (to get their votes).

The immigrants worked as railroad laborers, construction workers, small-scale fruit and vegetable peddlers, shoemakers,

and barbers. Both men and women were engaged in the needle trades, and Italian Socialists were among the leaders in several Chicago strikes by the Amalgamated Clothing Workers Union in the pre-World War I period. It was unusual to find Italians employed in factories. Only a minuscule number worked in meatpacking plants.

The Italian communities of Chicago were enriched by a phenomenon all too rare in their towns of origin—voluntary associations. By the 1920s, in addition to the *paesani*-based mutual benefit societies, the Italians in Chicago had church and school-oriented clubs and sodalities (which worked at fundraising), as well as special interest organizations sponsored by the settlement houses. According to Humbert Nelli, the general prosperity had just about completed the Italians' social mobility by 1929.

No treatment of Chicago's Italians would be complete without some discussion of the city's most (in)famous Italian American—Al Capone. The image of this gangster, who for 20 years operated a vice, gambling, and illegal liquor empire under the bribed consent of the city's non-Italian political leadership has besmirched the name not only of Italians in Chicago but of the city itself. A showoff, Capone fancied himself a Robin Hood, passing out cash at social functions and establishing soup kitchens for the destitute. Though the numbers directly involved in syndicate crime were less than 1% of the Italian American people, the Capone mob captured the imaginations of journalists and moviemakers who helped create a negative stereotype, which continues to haunt people with Italian names a half century after Capone's death!

On the whole, public opinion of the Italian immigrant in the 1920s was a negative one. Poverty, ignorance, blackhand crime, and prohibition-related violence were the chief ingredients in the public image of Italians in that decade. Even the most sympathetic saw Italians in the city as suitable objects for social work, charity, and rehabilitation—perhaps a more negative image than the criminal stereotype.

In the mid-1920s, Italians in Chicago still maintained their *Italianata'*. Their language, their family patterns, and their religious practices were retained in their old neighborhoods even while they were Americanized by their daily contacts with non-Italians (mostly immigrants themselves). Mussolini and Fascism reinforced *Italianata'*. In fact, the proudest moment in the history of the Chicago Italian colony came in July 1933, when Italo Balbo's squadron of planes completed their transatlantic flight, landing in Lake Michigan as part of the World's Fair activities. The event and the activities surrounding it put Italians on the front page—in a positive light for a change. Until the declaration of war between the United States and Italy, support for Mussolini was high. Then things changed, the second generation marched off to war, and vocal support for the Fascist regime died out.

Roughly speaking, what might be called the second generation emerged in the 1920s through the 1940s. Born in Chicago, educated according to American and/or Catholic standards, influenced by the Prohibition of the 1920s, tempered by the Great Depression, and Americanized by service in World War II, this group was often ambivalent about ethnicity. Middle-class America had always frowned on their parents' language and customs, and now came the War.

World War II changed everything for Italian Americans. It Americanized the second generation. The G.I. Bill opened up the first possibilities for a college education and the first opportunities to buy a new suburban house. Other government policies such as urban renewal, public housing, and the building of the interstate highway system combined to destroy their inner city neighborhoods. First, there was the construction of the Cabrini Green Housing Project, which helped to drive the Sicilians out of the Near North Side in the 1940s and 1950s. Then came the construction of the expressway

system on the Near South, West, and Northwest sides, which dislodged additional Italian families and institutions, including the church and new school of the Holy Guardian Angel. The exodus headed west along Grand Avenue, eventually reaching Harlem Avenue. In the early 1960s, Mayor Daley decided to build the new Chicago branch of the University of Illinois in the Taylor Street neighborhood. Almost simultaneously, the Roseland-Pullman Italian community fell victim to real estate blockbusters who profited from the expansion of the African-American ghetto by scaring white residents into abandoning their neighborhood and their new Church of St. Anthony of Padua.

The overall result of all the positive and negative forces during the post-World War II era was that, except for a few noteworthy pockets of Italian settlement, Chicago's old Little Italies were destroyed. With them have gone the sentimental sense of identity and security that the continuity in customs and familiar faces of the old neighborhood offered. Whatever political power the Italians could muster from geographic concentration was also undermined. Henceforth, there would be no geographic base for the community. A smaller community of interest, based almost entirely upon voluntary association and self-conscious identification with Italianess replaced this.

One of the first to perceive the change and to plan for it was Fr. Armando Pierini. Easily the most productive leader in the history of the Chicago Italian community, Pierini began serving at the Scalabrinian Santa Maria Addolorata Church in 1935. Within a year, he founded a seminary to train Italian-American priests to minister to their own. The Sacred Heart Seminary trained future priests, and it educated young men who became Italian community leaders.

Pierini also used the same citywide approach for his next project—an Italian old people's home. Proposed in 1945, Villa Scalabrini opened in 1951. From that time forward, there has been a continuous and intense campaign to create an Italian community and to unite that community behind a common noble cause—The Villa Scalabrini. In the 40 years since the Villa was proposed, Italians from various parishes and various parts of the metropolitan area have cooperated to stage an endless stream of carnivals, dinner dances, stage shows, fashion shows, spaghetti suppers, cocktail parties, and golf outings to support this multimillion-dollar institution, which stands as a proud testimonial of what Chicago Italians can accomplish when they are united.

The campaign to support the Villa also resulted in the 1960 establishment of *Fra Noi* (Among Us). A monthly English language paper, *Fra Noi* functioned as a house organ for the Villa. Featuring local articles on politics, people, organizations, major contributors to the Villa, sports, recipes, and cultural and religious topics, *Fra Noi* has in its 400 issues reinforced a sense of Italianess and community among its 12,000 subscribers and their families. In 1985, *Fra Noi* passed from Pierini into the hands of the third generation professional journalists who have broadened the paper's circulation, advertising revenue, intellectual scope, and even the size of its Italian language section. Given the current geographic dispersal of the 300,000 Italians in the Chicago area, it is hard to conceive of any meaningful way in which the term "community" could be used to describe that population if *Fra Noi* and the Villa did not exist.

A brief demographic analysis of the Italians in the city in recent times yields varied conclusions. Census figures for 1970–1990 show Italians in the city to have above-average incomes and to be slightly under-represented in the professions. Other studies have shown the Italians along with the Poles, African-Americans, and Hispanics to be woefully under-represented on the boards of directors of large corporations. Figures for educational attainment show Italians below average, but this can be explained in part by the fact that the oldest

cohort of Italians had little or no education.

The highest concentration of people of Italian ancestry is in the Dunning, Montclare, and Belmont-Cragin areas of the northwest edge of the city limits, where approximately 20,000 of the 138,000 city Italians live. This 40-block area is shared with second and third generation Poles but contains hardly any African-Americans. The ambiance of the neighborhood also reveals the ethnicity of the zone. It features a large grocery specializing in Italian imports, a genuine Italian-style bar (Bar San Francesco) complete with espresso, gelato, and cardplaying Calabresi in the backroom. Many of the stores and businesses on Harlem Avenue are owned and run by Italians, many of them recent (1970s) immigrants.

Both the statistical and the impressionistic evidence point unmistakably to the fact that the era of the poor Italian American is long gone. They are financially comfortable as a result of success in family business, the acquisition of a skilled trade, or through unionized factory work. Moreover, the under-consumption of previous generations, the slow accumulation of real property, and family economic cooperation reinforce their economic status. They have achieved the American Dream, except for one thing— respect.

Attaining their final goal is the stated, or unstated, purpose of the hundreds of voluntary associations which Chicago Italians have formed. Prominent among these is the Joint Civic Committee of Italian Americans (JCCIA). It was established in the 1950s, in response to an effort by the Democratic Party to drop a respected Italian-American judge from the electoral ticket. An important part of the Capone legacy is the assumption in the public mind (and among Italian Americans themselves) that every successful Italian American is somehow "connected."

The JCCIA, since its founding, has maintained an office with a director, a secretary, and volunteers, and is generally conceded to be the spokesman for the Chicago Italian-American community. Its Anti-Defamation committee has used an effective combination of quiet influence, outraged protest, and award-giving flattery to nudge the news media toward more objective treatment of Italians. One major achievement has been the cessation of the use of Italian words such as "Mafia" and "Cosa Nostra" in favor of the more neutral "organized crime."

Oriented toward the regular Democratic organization, the officially "nonpartisan" JCCIA's major patron was the late Congressman Frank Annunzio, who fashioned for himself on the national scene the role of "The Leading Italian-American Congressman." The most important annual function of the JCCIA is the Columbus Day Parade, which attracts almost every politician in the state regardless of race, ethnicity, or party. The Columbus Day event shows off the Italian community's power and influence.

In the early 1960s, the JCCIA forged an alliance with the Villa and *Fra Noi,* which gave increased credibility to all concerned. Together the agencies have sponsored a dizzying array of cultural, folkloric, and social events that range from Italian language classes to debutante balls.

The Italian-American horizon in Chicago is filled with hundreds of clubs and organizations that reinforce and promote Italian identity. A short sampling will suffice to illustrate their range and depth. The sampling follows: the Italian American Chamber of Commerce organized in 1907 to promote trade between Italy and the United States and to help Italian American businesses; the Justinian Society of Lawyers; the Mazzini-Verdi Society of mostly Lucchese businessmen has a clubhouse with carpeted bocci courts; the Maroons Soccer Club has a satellite dish that receives Italian Soccer matches live at 7 a.m. on Sunday mornings; at the monthly Sunday morning meetings of the Amasenese Society, the debate is conducted in four languages—standard Italian, Italian dialect, broken English, and standard English; the JCCIA Young Adults Division plans ski trips and moonlight bowling

events; each Labor Day weekend sees celebration of the feast of Santa Maria Lauretana, complete with a procession and the flight of the angels (children suspended on 30-foot high pulleys). A dozen Italian language radio programs hit the airwaves each week, and the Italian Cultural Center sponsors art exhibits, scholarships, and Italian language classes for children and adults. More recently, FIERI (Proud Ones) has become the organization for younger Italian-American professionals. The Italian American Political Coalition and the Italian American Sports Hall of Fame are also prominent.

These activities and organizations do good works—they contribute to Italian-American cultural projects, and they offer small scholarships to young people. More important than the good they do is the recognition that they bring to their leaders and their members. For it is in this kind of manageable social matrix that ethnics and non-ethnics alike can find the fellowship, recognition, and respect that most of us find so elusive in the larger social arena of the metropolis with its millions of inhabitants.

Religious street festivals have been the most outstanding characteristic of old Italian religiosity in America. Parading the graven images laden with money pinned to their garments was shocking to Protestant Americans, and more than a little disturbing to the Irish Church hierarchy and even some Italian priests. Twenty years ago, the number of such feasts had dwindled to a mere handful, but in recent times there has been a resurgence in the number and intensity of these celebrations. Religious events, these *paesani*/clan-oriented activities have mixed charitable and commercial purposes. Revenues encourage and support Italian American cultural and charitable activities— intensifying and perpetuating the identification of all participants with things Italian. Ethnicity is nothing if not symbolic, and the *feste* themselves, laden with ancient symbolism, proclaim a convincing challenge to all who would dismiss the significance of Italian-American ethnicity in Chicago today.

Italian Americans have not been successful in getting elected to major posts in the city or in the State of Illinois. There has never even been a serious Italian candidate for mayor of Chicago. Until 1978, no Italian American had ever been slated for a statewide elective office. Jerome Cosentino was the first to break that barrier when he ran and won as a Democratic candidate for State Treasurer. More recently, Al Salvi's bid for U.S. Senator in 1996 was disastrous. Italians have been luckier getting elected as state legislators, county judges, and suburban mayors. The number of Italians in the larger electoral units has never been great enough to challenge successfully other ethnic groups, and the Mafia image has made it difficult for Italian politicians in larger districts. However, in electoral units such as the city wards and the suburbs like Chicago Heights, Blue Island, Evergreen Park, Elmwood Park, Highwood, and Melrose Park, Italian Americans have been successful.

Issues don't seem to matter. At a Chicago conference of Italian American elected officials, participants were hard pressed to name specific Italian-American issues or causes that shaped their politics, except of course for the anti-defamation issue. All Chicago politics is based on place and influence. The one time an Italian issue did emerge in the 1960s, when Mayor Daley decided to tear down the Italian neighborhood to build a university, the Italian elected officials went along with the deal, leaving only an heroic housewife, Florence Scala, to lead a fruitless battle to save the neighborhood.

If Italian Americans have been thwarted in their political ambitions, they as individuals have compensated in other fields. The litany of ethnic achievers gives a clear sense of the dynamic roles played by Italian Americans in Chicago society. The list also provides some role models for emerging leaders and will influence the future of the community. The sainted Mother Cabrini died in a Chicago

hospital that she founded. The previously mentioned Capone distinguished himself in his field and has become a role model for all too many Americans. Nuclear scientist Enrico Fermi was a Chicago Italian. More recent stellar achievers include Dominick DeMatteo, who parlayed a small grocery into the gigantic supermarket chain that bears his first name. Anthony Scariano served in the OSS in Italy and as a popular independent liberal in the state legislature. He later served on the Illinois Appellate Court. The late Dino D'Angelo, born in Castel di Sangro in the 1920s, conquered mental illness, then created a real estate empire that included the Civic Opera House. D'Angelo's philanthropy toward various universities and hospitals approached the $10 million mark. His brother, Oscar, is regarded as one of the most influential developers in the city. Our list continues with former Federal Judge Nicholas Bua, whose courageous decisions have outlawed political coercion of city and county employees; the late Cardinal Bernardin; Virginio Ferrari, a Veronese minimalist sculptor; Professor Robert Remini, winner of the American Book Award for his three-volume biography of Andrew Jackson. The list is longer; we could add former State Senator Aldo DeAngelis, bread magnate Ron Turano, the late Cardinal Bernardin, the late sportscaster Harry Caray, Anthony Tortoriello, fuel supplier, and writer Fred Gardaphé. The point is clear that there is an abundance of Italian Americans achieving at the highest levels in Chicago society. To varying degrees, each of these current leaders maintains a sense of *Italianata'* that they transmit to the general public, and (more importantly) back to the Italian-American community in their lifestyles and through the ethnic media such as *Fra Noi.*

We have in the Chicago area about 500,000 Italo Americans of various generations. That is about the population of a medium-sized Italian city. Though the group has been in the city for about a century, it maintains a lively array of civic, religious, and cultural institutions, and organizations that provide a sense of ethnic identification and recognition in a manageable arena inside the larger metropolis. Because the institutions perform the psychic function of allocating recognition, they will not die or fade quickly from the scene. Moreover, the more tolerant cultural climate toward ethnicity, the increased interest within the third and fourth generation in ethnic roots (travel), the promotional interests of the Italian government, and the intrinsic attractiveness of the Italian lifestyle together produce a powerful cultural force indeed. And judging from the success of the *Fra Noi,* future Chicago Italians might have an even stronger and more sophisticated ethnic identity than their second-generation grandparents.

Pictured is a bust of Cardinal Bernardin executed by the Italian Cultural Center Mario Spampinato.

FATHER ARMANDO PIERINI

Defines the Italian-American Community in Chicago

*"When the Lord wants to do something, He chooses the worst individual that He can find. . .
That He chose me, I don't know why."*

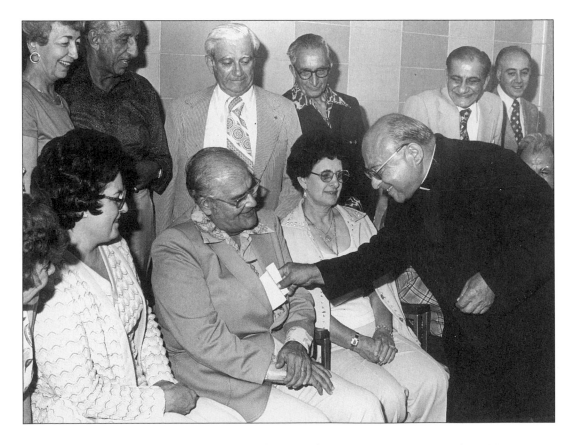

Pierini tucks a going away present into the vest of Joe De Serto. For more than 20 years De Serto and Pierini teamed up to raise funds and promote the Villa. Seated are Gina Pendola, De Serto, and his wife. Standing are Jean Wilson, Joseph Fusco, Joseph Panteleo, Tony Nicoletti, Peter Pendola, and Peter Sarangelo, 1976.

Father Armando Pierini was, without question, the most important Italian religious leader in Chicago. He founded the Sacred Heart Seminary, the Villa Scalabrini, and the *Fra Noi* newspaper. Suprisingly, he was personally very humble and in this interview takes no personal credit for managing these vast projects that defined Chicago's Italian-American community in the twentieth century. Yet he had a shrewd sense of business and marketing, and his ability to attract supporters from all segments of the community is unmatched. This interview was done in 1983, in conjunction with an unpublished history of the Villa Scalabrini by the author. Some of the material also relates to an article about *Fra Noi* by the author, which appeared in Volume 23 of the Proceedings of the American Italian Historical Association.

FR. PIERINI MAY 25, 1983

My father was a *contadino* in Agello. I left for the seminary in 1922. I was 14 years old. I studied Italian, geography, Latin, Greek, and French. Five years of gymnasium, three years of college, and four years of theology, and a year at the Gregorian University. I came to Chicago in 1933. I was 24 when I was ordained. I came to Chicago, Santa Maria Adolorata, on May and Erie Streets, as an assistant. I stayed four years and a half. The Province established the Sacred Heart Seminary in the old rectory of Adolorata rectory, to provide priests for the Italian-American community. We got some, but to become a priest is a hard thing. We didn't have *too* many, though we did have some. For the number of Italians that we are in Chicagoland, the number of priests or of nuns is insignificant. We have a lot of professionals, dentists, and doctors, but the priests are relatively few.

We encouraged them to learn and go to school, but through the history, our Italian people who came over here were not so religious; therefore, they did not care too much to send their sons to become priests. The Scalabrini fathers have saved the faith of most of the Italians that still have it in Chicago. There was a time when we had 10 churches. In 1933, the parishes were well established. . . . It was all the faith. Fr. Benjamin Franch, the Provincal Superior, Fr. Remigio Pigato (Pompeii), and Father Ugo Conichi were of one accord that we needed to start a seminary to get Italo American priests.

I was chosen to be rector because there was nobody else, and I remained rector of the seminary for 11 years. It was completed in May 1937. We got funds from collections, offerings, and savings of the fathers. We had lay teachers—I taught a lot of the subjects myself without knowing too much about them, but that's the way it goes. The students lived right there. The third floor was dormitory, the second floor was classrooms, and the first floor was offices and chapel. In 1939, we built the convent, dining room.

We started with about 10, and then it went up to 40 or 50. The inauguration was the 9th of May 1937. Big crowds of people came with buses. We had the main rector of Italy, and there was Bishop O'Brien. It was a tremendous success. We built the Calvary Shrine; we built the Stations of the Cross. . . . There was a depression in the land, and we could either fill it or dig it and make a lagoon. Filling would be expensive, so we decided to dig it ourselves. The task proved almost impossible, but we piled it up to make the hill for the shrine, and we dug a well that made water for the lagoon.

People would come to me and ask, "Father, what do we do now with our old people?" It was the end of the war, and the soldiers were coming back, and there was no room. The old people have to go somewhere. At that time, there were very few old people's homes anywhere. Besides, our Italian people felt uncomfortable in those homes because of the language,

religion, the food, and the traditions. One of the ladies was declared incompetent because of language. When she was not understood, she used to get angry and refused to talk, and they had her declared incompetent. But when she came over here (Villa Scalabrini), she was mentally 100%. So it was necessary to have an Italian old people's home for our people. In 1946, there was a meeting at the seminary of all the reps of community and Italian churches and our Fathers, and there were some that wanted to build a high school for Italo-American boys. At that time, there was a need felt that we could have a high school for our Italo-American boys. After mature discussion, the idea of an old people's home won over, because it was much more necessary. After all, there were enough high schools for the boys, but there were no old people's home for the aged.

Before going any further, we had to get the permission of the archdiocese. And they said "yes, you can build an old peoples home for $300,000, but you have to have cash." They did not trust the Italian community and the Fathers too much. But they gave us permission, and so we began with a house-to-house, door-to-door collection. There was John Cangelosi, who was a painter of churches; Marco DiStefano; Joseph DeSerto—he embraced the idea with all his heart and mind, a very good man, a very good organizer—dedicated to detail; and there was Judge Sinese, who was Justice of the Peace in Melrose Park. They were all my right-hand men. They were working people, and more than that, the Providence of God wanted a place like this (Villa Scalabrini), and when you have the will of God with you, no matter how insignificant you are, things will go through. And they went through.

One time, we went to Cardinal Stritch—he was the superior; he was the boss. Marco DiStefano was the spokesman. He asked him if the future old people's home could be the property of the Scalabrini Fathers who had been here for 75 years. But his Eminence said "No." Cardinal Stritch told us also that

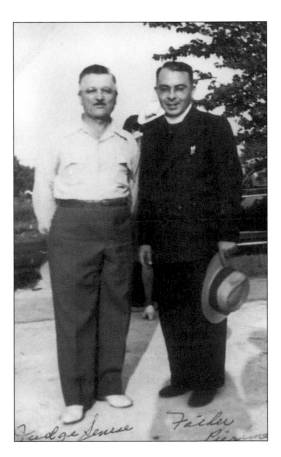

Fr. Pierini is pictured with one of his earliest confidantes and supporters, Judge Sinese of Melrose Park. Sinese's involvement originated with the construction of the Sacred Heart Seminary in the mid-1930s.

we should extend this idea to all the other Italian churches, like Holy Rosary, St. Philip, Assumption Church, Precious Blood Church downtown. Some of those Fathers did not accept the idea at all. It remained the project of the Scalabrini Fathers.

The first big public doings was a banquet at the Hilton Hotel (1946). We had established $25; at that time it was a fabulous ticket price. It had never been done in the Chicago Italian community. Father Pigato and Father Giambastiani (St. Philip Benizi) came to see me at the WGES radio station. They said, "Father, you have to cancel the

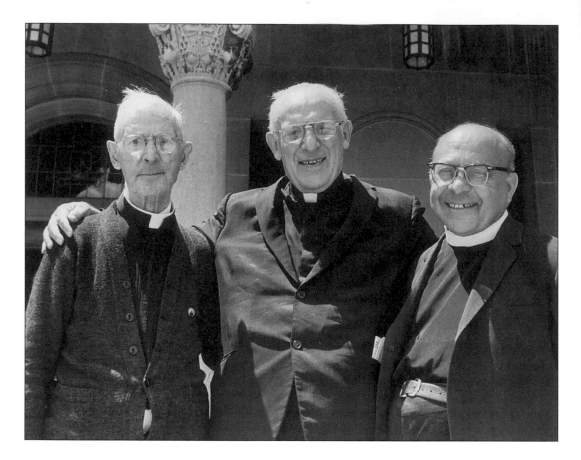

Father Luigi Giamsbastiani and Father Pierini congratulate Father Joseph Chiminello on his fiftieth year as a priest, 1974. The continuity of service of these three men is remarkable, representing some 150 years of leadership of Chicago Italians.

date with the hotel because it would be a shame if we don't succeed, and we cannot succeed. Tickets are too high. People don't know the cause yet." I was stubborn. I said, "Let it be what it will be," and we did not cancel the date. Then Father Pigato went about selling tickets. That night, it was a sellout—even the balcony. We had 1,300 people there. We collected $56,000. It was a good start. Rep. Roland Libonati gave a speech, and Cardinal Stritch was the guest of honor.

We had banquets like this up to 1970. After, it became too expensive. We had one banquet one time of 4,000 people at McCormick Place; the bill at the time was $40,000. It was too much going for the expenses.

Before that, we had the carnivals. That was a good way to raise money. The idea of a big carnival, festivals, was Father Louis Donanzan's, who had experience with festivals in Kansas City, Missouri. It went over in an unthinkable way—it was fantastic! We had maybe over 100,000 people for 12 days. People came in waves, and we had stands and big bands. We had over 500 people that came every single night from the Scalabrini Churches to serve, to cook, and to help out. The Italian people wanted an old people's home for their old folks! They were there to work and also to spend.

To promote the carnivals, we had handbills. We had the Italian radio announcers, who were 100% for the idea. One of the reasons I started my radio show (1946) was exactly that—to carry the idea of the old people's home to Italian people after all these festivals. We got the places for the festival always free from the owners—Cicero and Roosevelt, Chicago Avenue and Laramie, Karloff and Grand Avenue. Then we ended up in the parking lot of the Maywood Racing Track.

The money came in, and we began to look for a site for the old people's home. We went many places. We decided to buy some lots on 38th and Division, across from the seminary. It was too small. We didn't stay in the city because we wanted to have a good place; we wanted to have some green; we wanted to be able to breathe because the Italian people didn't come from the cities, they came from the towns. That was my personal idea too. My idea of an old people's home was not only to take care of the old people, but also that the Italian community should have a place of which to be proud, which they can talk about, for their morale, not only for the old people, but for the whole community.

The Lord was always with us. We heard that there was up for sale the Westward Ho Golf Course, and we bought 40 acres at Wolf and Palmer. We bought the clubhouse (hoping that we could use it) for $100,000. We exchanged and ended up with 16 acres for $9,000. Now it would cost at least $5,000 an acre.

We wanted a home for 275–300 people. We had a contest among the Italian architects that wanted to participate. We had cash prizes, and we had five of six that responded, and the architects of the Chancery office, and the fathers chose the design of Mr. Frank Serpico. We wanted something Italian. We wanted something one-floor. We wanted it to be nice and big and good looking. We gave it a lot of thought, and I'm still pretty happy about it. Phase I was dedicated July 1, 1951, with facilities for up to 90 people.

We had 50–60 chairmen for the carnivals. Then after two or three years, we hired professionals—the Vagabonds, we had Rocky Marciano, we had Dick Contino. We had Jimmy Durante and Connie Francis for banquets. Frank Annuzio had an in.

From January, Joseph DeSerto, he came in with the contracts—a tremendous job. The volunteers were for some of the stands—the food, the drink.

We had to give it a name. I went to Cardinal Stritch—after all, he was the boss—and he suggested that we call it "Bethania," which means a house of repose. I said, "Your Eminence, we would like to name it after Bishop Scalabrini. He did so much for the immigrant we are sure that one day he will be canonized." And immediately he said yes. This was the first home built for the Italian aged.

Villa Scalabrini was such a success that there was a long waiting list. Ah, the waiting list. That was one of my biggest crosses to bear. If nobody passed away, there were no beds available. So some people say you're discriminating. It was not so. Of course, there might be someone who gave $100,000, and he recommends one particular time somebody—well, what do you think, that I don't try to make an exception? You have to know where your bread and butter come from, too. I didn't feel guilty that I was making an exception. But usually it was first-come, first-served. There was a time when we had over 200 people on the list. But that number doesn't mean too much, because old people can't wait too long. Either they go in another place, or they pass away. In the beginning, I suffered quite a bit about it, but after I got used to it, I said (to myself), "Do your duty and forget about it."

We never kept anybody away because you had no savings or money. We never made a (request/requirement) that they should leave money or property to Villa Scalabrini when they died. Never.

There were some of the fathers who said, "Now let's stop!" after we dedicated the first

Father Pierini's dream of a first-class facility for the Italian aged is expressed in this drawing in Northlake.

wing, and I said, "How can we stop? For the need of the community, we cannot stop!"

The Lord wanted this. Little by little, the momentum for the Villa grew. Radio started 1946. . . we wanted a religious. . . we had to find a way to keep the Villa before the eyes of our people. . . we had Stefano Luotto. . . he was a very wonderful man, cultured, a good Catholic, and he had every day four or five men from the Villa on radio. And there was Americo Lupi and Serena Notari—she's still alive. Mr. Faustini. They were invaluable.

The first thing in broadcasting was religious and as the voice of Villa Scalabrini. We bought time from WGES once a week at 9:00 in the evening. It was prime time for radio. In 1961, we went to WOPA, and then a few years ago we went with Liberati, and now I have three programs a week and on Sunday at 1:30 p.m. In the beginning, we had priests as guests, and after that I had somebody who

sent me the Vatican radio programs.

It was in the first year that the Villa was built (1951), I received a letter in Italian handwriting. There was no return address with my name misspelled; for the address, it contained 22 $500 gold bills. I had never seen them in my life because they had been withdrawn. When I saw that, I thought somebody was playing a trick on me, so I called up the bank, and he said, "Oh, yes. Bring them over here. They must be good." Five hundred dollars for the Catholic Hour radio program, 500 for masses, and $10,000 for Villa Scalabrini. And the letter said in Italian, "I will know that you have received this donation if you say 'your pledge received' on your radio program." After that, I received another $3,000 that way, and I have an idea that it was the same person. I don't know who it was. That, of course, was another sign of Divine Providence. Right

now, I have somebody who is up to $7,000. Every Christmas he sends a cashiers check signed "buona fortuna." It's over $2,500 each time.

All the people who have given over $500 for Phases I and II are inscribed in the plaques in the vestibule of the church, and I am starting now to give that same recognition for the people who gave for Phase III. Part of the function of *Fra Noi* is to recognize, and to encourage at the same time, the people that might give, and we used to do that on radio too.

The second generation, they don't listen to the Italian radio programs, but Italian Italians, they listen to radio very much. I don't know how many listened to the Italian Catholic Hour—there is no way to find out, because our Italian people don't write back. I was just sowing the seeds, hoping that it falls on good ground, at least part of it. And then look at [radio broadcaster, Angelo] Liberati. In only three days, he took in over $60,000 through the radio, collected for Prioli (an Italian boy who was brought to Chicago for treatment of a rare liver disease). That's unbelievable.

The response to *Fra Noi* was close to 12,000 subscribers. If they don't receive it, they call. Once a month is too far apart, but we don't have the funds or personnel. I had an idea once upon a time to have a magazine like *Attenzione*—now an impossible dream. *Fra Noi* doesn't have an organization, but there are people like Sorrentino who send in their news, and we manage to print 24 pages. It hasn't missed one month since 1961.

I began the *Fra Noi* project by creating a list of Italian names, staying up nights, copying from the telephone directory and

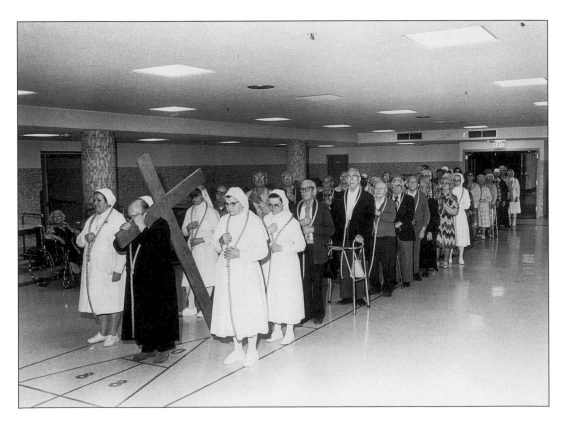

Father Pierini leads the Villa residents in a Good Friday Procession.

the polling lists. I photocopied 87,000 names. Then I didn't have the money to start with. I had put aside $25,000, but I was told to give it back to the Province because we cannot afford that kind of money for something that we are not sure of. Some of that list was faulty (because of the building of the expressways), so when I began to send it out, I sent 41,000 copies for nothing—hoping that people would like something like that, and they would subscribe for a dollar. But they didn't. We came down to 12,000, and that seems pretty steady. It's an active list. Father Paul Asciolla had a flair for that kind of thing. He was my assistant, and he took *Fra Noi,* but then he went his way and I had to take it over again. And then Father Cozzi came over here and I did the same thing with him, and then he got too busy. You know it is not too much of a pleasure to put together a paper, and I had to take it over again.

It's printed by a commercial service in Des Plaines. Whatever the clubs send, we never refuse to print it, and we have ads—a pretty good number. They call us, and we are not too cheap.

When the Lord wants to do something, He chooses the worst individual that he can find. That's theology! That He chose me, I don't know why. I was the worst, most useless, and He put around me a big number of tremendous people, well intentioned, hard workers. They did everything. I didn't do much; I am not a speaker. I am not a writer. I am mostly stupid, but it was because

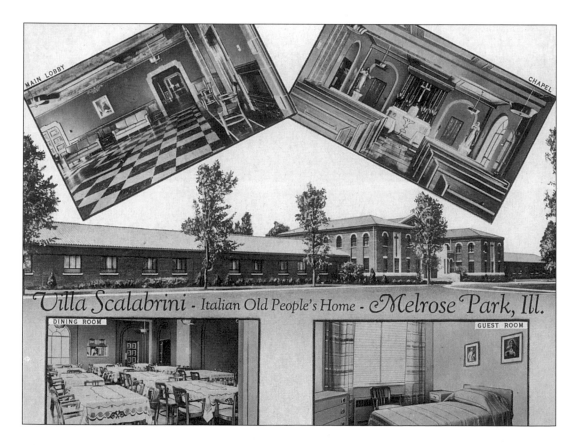

This postcard from the 1950s promoted Villa's modern facilities, its plans to expand from 95 to 200 residents, and the high quality of care offered by the Sisters of Saint Charles.

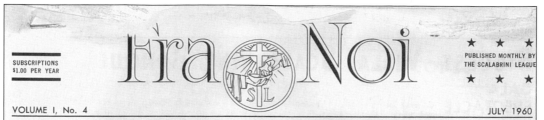

Fra Noi

SUBSCRIPTIONS
$1.00 PER YEAR

★ ★ ★
PUBLISHED MONTHLY BY
THE SCALABRINI LEAGUE
★ ★ ★

VOLUME I, No. 4

JULY 1960

FUN AND LAUGHTER AT VILLA SCALABRINI

LIFE AT THE VILLA

We have often observed the impression of the visitors who see the Old People's Home for the first time. The reaction is as varied as the individuals themselves. To all it is quite an emotional experience; we have seen men and women disturbed and others with tears in their eyes.

There is no doubt that old age disrupts the body, the senses and the mental faculties. The eyes become cloudy and the ears grow dull; the hands move clumsily and the legs are shaky; the heart and lungs require more care and tire much faster; the intellect loses its sharpness and the memory its precision.

laying Cards (left to right); Antonio Molinaro, 80 years old; Ernesto Dalla Giacoma, 88; Andrea LaPorte, 75, and Panfilo Di Domenico, 82.

To think however that old age is synonymous with misery and unhappiness is a mistake. Similar to the other stages of human existence, old people find many compensations and advantages. They can relax, laugh and enjoy themselves much as their children and grandchildren.

This is the experience which we have acquired in nine years

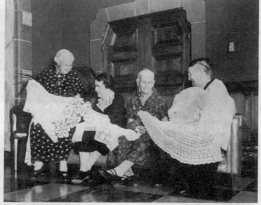

Proud of their beautiful, artistic products are (l. to r.): Teresa Bonacci, 87 years old; Maria Bondi, 78; Jennie Gagliardi, 76, and Gelsomina Borelli, 78.

Working in the garden is healthy, profitable and lots of fun (l. to r.): Lucia Beniggi, 78 years old; Francesco Speculatore, 89; Enrichetta Granata, 75, and Urbino Di Giuseppe, 77.

Have You Mailed Your

HISTORY OF THE VILLA

(Continued from last issue)

The first Banquet in 1947 had been a huge success; the door-to-door collection proved encouraging, and the first Italian Festival with its good financial results had excited the whole Italian-American community. The committees were working with enthusiasm. Father Joseph Lazzeri, P.S.S.C., of S. Maria Incoronata Church was laboring day and night exhorting, pushing, entreating and receiving a wonderful response.

It was time therefore to take decisive steps. Many labored with the opinion that the beginning should be a humble one, perhaps with an old house, mentioning the example of our Lord who started in a grotto. Others however, considering that this would be the only public institution of the Italian-American Community, insisted that it be worthy of the community

FRANK SERPICO as well as of the old folks who had contributed so generously to its progress and development.

The latter opinion prevailed. The Italian old people's home would be a beautiful place of which everyone could be justly proud.

To be fair to all the architects of Italian extraction a contest was held. The winner would be awarded the task of designing the institution and

Volume 1 number 4 of the Fra Noi *in July 1960 featured resident activities, a recap of the history of the Villa, and a column by Anthony Sorrentino. Forty-one years later, Pierini's newsletter has become a 120-page monthly, published independently of the Scalabrini fathers. Sorrentino's monthly column still appears in the* Fra Noi.

25

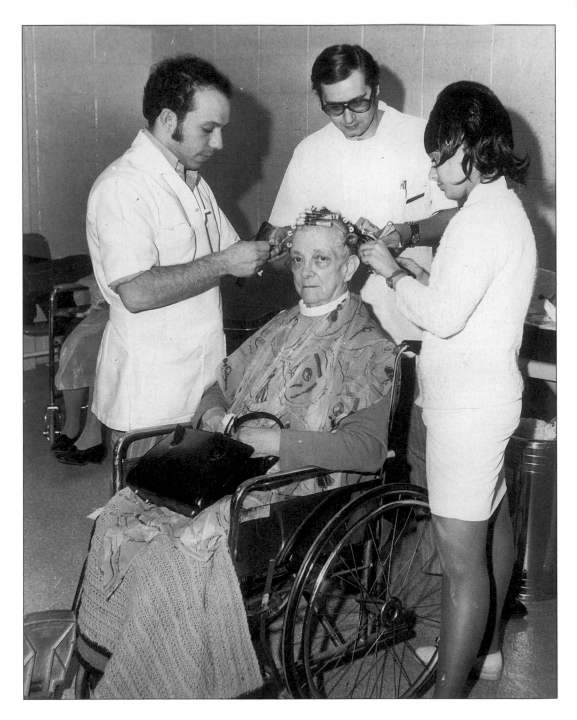

Fr. Pierini wanted the BEST for Villa Scalabrini residents. In this 1971 photograph, The Beauty Angels, Eugene Lucherini, Jerry Kosiba, and Carmeline Cesario treat Livia Vallesi to the works—a complete makeover.

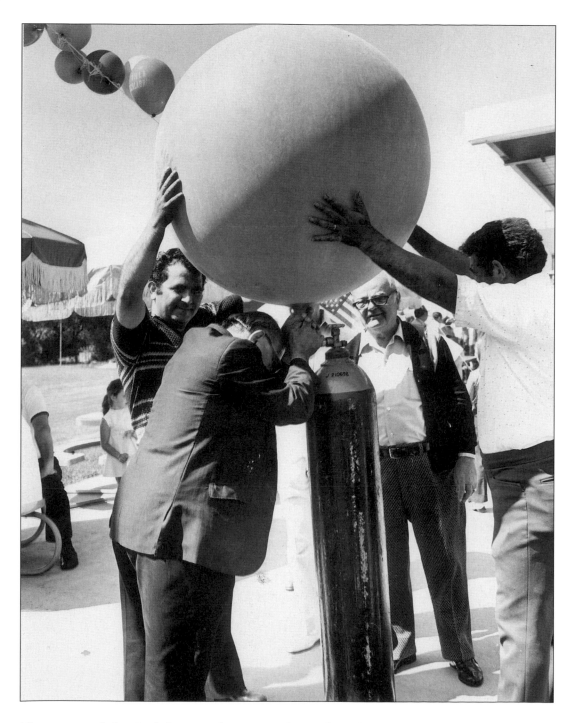

The motto of the Scalabrini order is "Umilitas," humility, and though Fr. Pierini had accomplished a great deal in the building of a seminary, the launching of a newspaper, and development of Fra Noi, he never got a big head. In fact, he was rather shy and self-effacing when groups attempted to honor him. He used bottled helium to inflate balloons for the 1979 Villa Picnic.

of these people. I think the Lord wanted the Villa to succeed. Just forget about me. In the beginning, I had some speakers, Judge Sinese and John Serpico—and then Frank Annunzio came along. He likes to speak! So he was the spokesman for everything. I stayed in the background.

We are not a civilized people if we don't take care of our mothers and fathers.

Paterno was a good friend. Groups like the JCCIA have become more cognizant of the ethnic organization. The Italian American general public has become more divided. We are scattered all over, and we cannot get hold of them these days as we could before. We are still a viable community.

I was discouraged many times; we had debts to pay. All my life, I had to collect money, all my life, and sometimes we get very discouraged. But as soon as I came back and saw all that the sisters and the staff did for the old people, then all my difficulties disappeared, and I got new courage to go on and do the best that I can.

Oh yes, as long as I could, I wanted an all-Italian staff because they could speak to the old people! We had an Italian doctor, Dr. Vincenti—everything was Italian, the food,

and wine. If you called it Italian, you have to have a little wine on the table.

We had one who was seeing ghosts all the time. We had a lady who was incontinent and always insisted that we call the plumber because there was water on the floor. Very good people, and very ornery ones too. In the early days, we were also cheap—cheaper than any other old people's home around, provided we could get along.

It is not that they bring them over here because they want to get rid of them, they bring them here because of the necessities of the family. They cannot cope with the situation any longer.

There was a pretty rich man, a businessman who did not want to stay with the family. He was independent, and he was very happy here. Another, a graphic artist, unmarried—I don't remember his name exactly, I'm getting old. He lived alone in a room at the Villa. When he died, they found the will written, he had done in his own handwriting, leaving Villa Scalabrini almost $1,000,000. I didn't know him, and I never met him. What's the explanation? He left everything that he had.

Joe Camarda

Faith Makes His Community

"They had the picture of the Blessed Mother right above the altar—the way it's set up in my hometown."

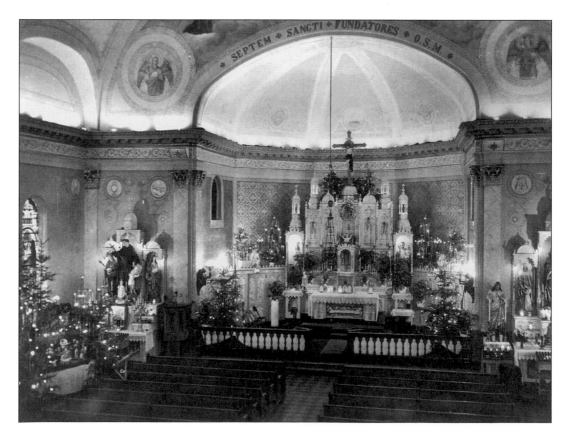

The interior of St. Philip Benizi is shown here at Christmastime. It was the placement of the painting of Maria Santissima Lauretana above the altar that endeared Joe Camarda to this church. (UIC IA 91.10.)

Joe Camarda is one of the leaders of the Maria Santissima Lauretana Society, most of whose members have origins in Altavilla Milicia, Sicily. Their feast has been celebrated in Chicago for over a century. Camarda, who runs a butcher shop, is typical of many Italian immigrants. His devotion to the Blessed Mother is extraordinary. He believes that devotion to Maria Santissima Lauretana has been the determining factor in the lives of his *paesani* and their successes in America. The family, the church, and the Lauretana Society have been the pillars of his life.

CAMARDA 2001

My mother was born in 1914, in Pittsburgh. She was one of seven children. Her father, Antonino Moreci, had a shoemaker shop—*calzalaio* or *scarpado* in the Sicilian dialect. He moved back to Altavilla in 1921, and took the whole family with him.

Joe Camarda, our narrator, is pictured in 1972.

My mother grew up in this small town, and my father lived around the corner from her. . . they fell in love. As a little kid, my father learned to be a barber because he didn't like farming too much. His dad, Giuseppe Camarda, had a lot of land that he was farming. My grandmother had eight kids—all boys. My father worked with the lemon orchard, and then he became a barber. When he got married, he opened up a spaghetti factory. He was the first one (in 1932) to open up a spaghetti factory in Altavilla Milicia—dried pasta made out of pure semolina. It was a small family thing.

Then the Second World War began. My father was drafted, and just at the start of his second term of service he was saved from being sent to the Russian front, because at that time Mussolini had this rule that any married man who was the father of four kids didn't have to serve. When my father was about to embark on the frontier toward Russia, my sister Rosalie was born. That makes four, and he automatically came back to town. In addition to the pasta factory, our family also had *generi alimentari,* (a food store). I started to help my dad, and we survived very well.

After the war, my mother and her brothers and sisters always regretted the fact that my grandfather took them back to Italy. All my mother's brothers and sisters were born here in the U.S.A., with the exception of one. After the war, everybody wanted to come back to this country (America). My father wasn't too interested, but my mother and my grandfather talked him into it. My grandfather said, "You got a family (at the time we were six kids). They are going to need opportunity. This town is too small." I did not agree, but I had to follow my parents' wishes, and they were determined to come here.

Before I left my hometown, I followed tradition and went first to kiss the Blessed Mother and then to the sacristy to say goodbye to the priests—Monsignor Melchiorre Gagliano, who was the Sanctuary

Pastor, and Reverend Salvatore Romano, who was the Monsignor's assistant. Monsignor Gagliano gave me his blessings, and he put his arms around me and told me, "Listen son. The first thing to remember is never forget where you come from. You're going to a real big country, a different world. You're going to see people from different races and nationalities with different beliefs, different cultures, different religions. You're going to be tempted in a lot of different ways. There will be times of uncertainty—temptation—times when you think you might fail. Always, (he pointed to the Blessed Mother), always remember." He said, *"Rivolgiti a Lei.* (Turn to Her.)" Of course, I had the picture in my wallet already, which I took with me. She was always with me, as were the teachings I got from my grandparents and my parents. I'd like to believe that every *Milicioto* did the same thing I did, and we are really fortunate people.

I was 18 in 1951. My uncles and their families came too. I got a job at Curtis Candy Company, making Baby Ruths. I couldn't speak English, so I had the worst job—working in the freezer. In the meantime, I learned a few words of English, and in a few months I got one of the most important jobs, operating one of the biggest machines they had. Then, later I became the foreman on the night shift at another plant they had.

We lived on Oakdale, near Wrigley Field. There were quite a few Italians and a lot of Sicilians. A lot of them had moved in the '50s from the St. Philip Benizi area, which was known as Little Sicily (where Cabrini Green is now). I never lived there, but I used to go there every Sunday for mass. I went there because that was the only Italian church that I knew on the North Side. The very first time I entered the church, I felt like I walked into my hometown church. Even though it was much different, they had the picture of the Blessed Mother right above the altar—the way it's set up in our hometown. The only thing that was missing were the steps that led to the Blessed Mother.

The people I met when I first came to this country (some were between 70–80 years old in the 1950s) told me my grandfather Camarda was in Chicago in about 1900, on the Near North Side.

I came in November 1951. By Christmastime, I was introduced to St. Philip's Church. The church was built in 1905, and celebrated its Golden Jubilee in 1955, shortly after I came to this country. Right on Larabee Street, we used to have our lodge headquarters. Our Maria Santissima Lauretana Society was always affiliated with St. Philip's Church. Altavillesi came here in the 1880–90s in Little Sicily before the church was even built. A week before September the 8th, they used to gather at someone's house and have the novena, the Rosary. Then on the day of the Feast of the Blessed Mother, they put an altar in front of the house and said the Rosary, but they didn't have a priest at that time. Then they would carry the image of the Blessed Mother around the block. I knew about the Lauretana Society back in Italy. My maternal grandfather, Antonino Moreci, was the treasurer of the sanctuary.

The bus went to Larabee Street. I used to get off on Oak Street, and I used to see where the lodge hall was. So there came along my first feast in Chicago in September 1952 (I was 19), and while I'm in front of the lodge, or Casa Madonna as we call it, here came along this man who was the president, Joseph Guagliardo. He looked at me and said, "Aren't you Milicioto?" I told him my name, and he said he knew my grandfather, and he said, "You belong here." I said, "I know I belong here, I grew up with it (the Lauretana Feast)." I soon became a member. He gave the little push—which I didn't need. I started with the society for the single reason that I wanted to help carry on the tradition.

The Feast in honor of the Blessed Mother took place at St. Philip Benizi Church on Oak Street and Cambridge Avenue, extending to

Larabee Street and Clybourn Avenue. I liked the way they used to decorate the street with festoons, banners, flags, and illuminations—just like the Old Country. It lasted four days, always four days. The lodge's first building was in 1916. This was about a block away from the church. There were food stands, toys, and we always had the flying angels, always.

Legend tells us that the celebrations go back to the 1630s. A pirate ship going toward Palermo encountered bad seas, and the pirates started throwing cargo overboard to make the ship lighter. In the cover of a barrel was this painting of the Blessed Mother. Not being Christians, they believed it was bad luck, so they threw it overboard. The people at the seashore, *la spiaggia*, the beach, found this and got excited. The people from different towns were arguing over who was going to take it. So they decided to get a cart pulled by oxen, and they put the painting of the Blessed Mother on the cart and gave the signal to the oxen to go wherever they wanted to go. The agreement was that wherever the oxen stopped, that's who takes the picture. From then on, we were blessed to have the oxen come to our town, and when they stopped, that's where they built the church.

Father Luigi Giambastini was appointed as an assistant to Father Pellegrino in 1910. In 1916, he was made pastor and served in that post until 1962. When the Cabrini Green project became black in the 1950s, white Sicilian and Catholic families moved out, and the once vibrant Servite parish became moribund—a victim of urban renewal. The building was demolished in the mid-1960s.

I was working nights at the Curtis Candy Company, so I found time to devote to the Blessed Mother. When I first joined the lodge, there was this elderly man, Mr. Muscarello, who was financial secretary. I was introduced by my name, and he said "Your name is Giuseppe Camarda, and you are from Altavilla?" I said, "Yeah." He said, "Which Giuseppe Camarda? The man with the mustache?" And I said, "That's my grandfather." When I told him he was my grandfather (my grandfather was here for four years), he said, "Your grandfather? He was my brother's godfather!" Then he grabbed me (to embrace), and I thought he was going to cut me in half. They were happy that I joined the lodge, and the following year they asked me to be assistant financial secretary. Whatever they asked me to do, I did. I was financial secretary two years, and then I was asked to be vice president. From there I was more in the spot, and I had to take over in 1966 as president. There was a lot of responsibility that I didn't even want it. I felt honored and privileged to be a part of the congregation to honor the Blessed Mother. But I couldn't bear the fact that I had to take over the responsibility as the twelfth president. All I wanted was to do the work of the Blessed Mother.

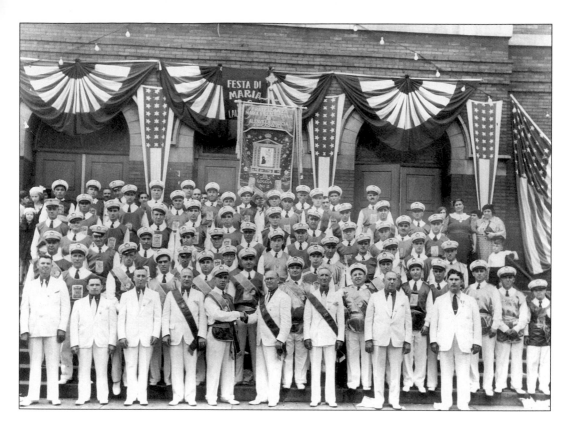

The uniforms, the decorations, the flags, and the banners exude a sense of identity, a sense of community and devotion that played no small part in the success of the Altavillesi in Chicago.

Going back to the tradition and the devotion of the *Milicioti*, there is so much devotion. I am telling you this as a true devotee of Maria Santissima Lauretana. I guess you have to be in it to believe it. Sometimes you talk, and people look at me like a fanatic. I'm far from a fanatic, believe me. I was born with this faith, and I know I am going to die with it. I had a lot of temptation, especially in this country, but nobody changed my way of thinking and my faith. The way I am is the way a good 99.9% of *Milicioti* are when it comes to faith in the Blessed Mother. You might not see the 5–10,000 living in Chicago at one time, but when it comes to the day of the Blessed Mother, they come to honor Her. That's what made them strong. That's what kept them going.

After the neighborhood was gone, there was nobody left. Our society was the last society to move out of St. Philip Benizi. The last feast we had at St. Philip Benizi was 1961. When the church was closed down, it was a sad day for everybody. Who you going to protest to? People were scattered all over. Father Luigi Giambastiani did all he could to keep it open. Father Luigi was an angel. Besides being the pastor of everybody—the devotion that he had to the Blessed Mother and the respect that he had for the Maria Santissima Lauretana Society was unthinkably (great).

Cabrini Green was already built (1961). The church was kept open about four or five more years, and then they had it demolished. I kept going to St. Philip's on

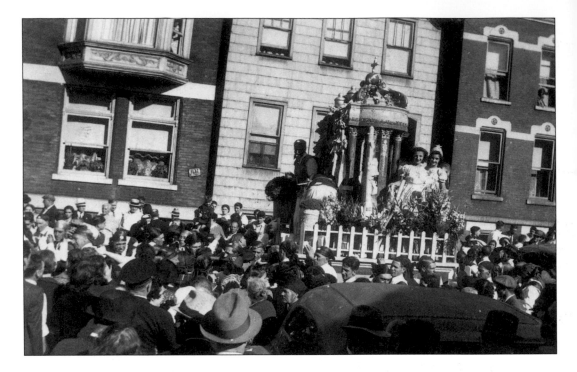

The Feast of Maria SS. Lauretana is depicted in 1936 in the old St. Philip's neighborhood. The narrow streets, the crowd, close quarters, and the ability to stage the flight of the angels from buildings across the street from each other provided a sense of excitement that made this one of the most popular of the score of such events at St. Philip. (UIC IA 186.26.)

Sunday. One day the new pastor said, "What are you doing here? You shouldn't come here. This is not an Italian church anymore." I told him, "No kidding. Maybe in your eyes. But as long as that picture is there and the church is open, I'll keep on coming."

The year 1961 was the last feast we had over there. The first feast we had away from St. Philip was right here at Saint Rosalie's Church in Harwood Heights. Father Conrad had just built that church. . . . We went to talk to him, and we explained everything all about our society. He was very devoted to the Blessed Mother also. He knew about our feast. He knew about St. Philip. He welcomed us with open arms. In fact, when I got the painting of the Madonna from St. Philip, we put in Saint Rosalie. I was the happiest guy in the world. In Sicily, the Feast of Maria Santissima Lauretana had a lot to do

with Saint Rosalie. The (1962) crowd, especially on Sunday, was unbelievable, but the neighbors started to complain because people stepped on their lawns. Especially in those days—at least now we got some Italian people there (Harwood Heights), but in those days, there were no Italians.

We had bought an empty four lots east of the church (St. Rosalie), and we were going to build our own club and chapel there. We were there only one year, not that we got kicked out, but we had to find a new spot.

When we moved from St. Philip Benizi, everybody in our community thought that the Lauretana Society was wiped out like the rest of them. We were the only one left. There were over 25 organizations who had their feasts there in those days, and from Good Friday to the end of October, there was a feast there every week—all Sicilian. The

biggest feast was Maria Santissima Lauretana. All those organizations were in decline when I came to this country. Some of them went dormant for 30–40 years, and then they came back again. Maria Santissima Lauretana has been here always, never stopped one day, even during the Depression, during Wartime, it was continuous, non-stop.

The worst time was when we had to leave from St. Philip's. Joe Maniscalco called to then-president, Joe Guagliardo, about a woman who had dreamed that the Blessed Mother told her to tell us, the *Milicioti*, that we were going to find a place near O'Hare Airport. Do you know where we found a place? In Rosemont. Do you know where the Hyatt Regency is? The first year (after St. Rosalie), we had it at Our Lady of Hope on Higgins and Devon, a triangle. In the meantime, the lady with the dream encouraged us—"The Blessed Mother wants you to celebrate." The daughter of one of the members of our society, Francesca Muscarello, had a conversation with the Pritzger family. Where the Hyatt is right now (River Road), it was empty land, and we had the feast there for five years. The mayor of Rosemont, he loved it! But (in the mid-1960s) they (the Pritzgers) decided to build, and we had to move.

We had a hard time finding a spot for the feast. That's when I called my brother-in-law, Carlo Reina. He contacted the owners of the Cermak Shopping Center, and through his abilities and because of his devotion to the Blessed Mother, that's how we ended up in Berwyn (22nd and Harlem). That's what our membership is all about.

Nineteen sixty-six, it was my first year as president and the first year the feast was in Berwyn. It has been there ever since. We always had the flying angels. Only one time we couldn't put them on a rope because of the location difficulties. You know what we did? You know White Way Sign? One of our officers was friends with the owner of White Way Sign, and we had two snorkels with the baskets. I wish I had pictures. The angels

recite a prayer to the Blessed Mother. Each one has seven parts.

Silenzio, Silenzio!
Silence, Silence (everyone)

Salute a te Gran Vergine
Greeting to you Great Virgin,
Madre dei peccatori
Mother of Sinners
Consola a questo popolo
Give counsel to these people
Che Vi prega con fervore
Who pray to you with fervor

O Maria Lauretana
Oh Maria Lauretana
Che in Chicago Sei arrivata
Who has arrived in Chicago
Consola questo popolo
Give counsel to these people
Da Chi Sei Festiggiatta
By whom You are celebrated
Festiggiatta Sei Sovrana
Celebrated as a Queen
O Maria Lauretana
Oh Maria Lauretana

(Rough translation is by the author.) That's only a part. There are 14 verses.

We choose girls by age, size, and they have to be willing. We start them when they are nine years old. Only twice we had to use a boy because we couldn't find a girl. There were times when I had a rough time trying to get kids for the flight of the angels. I'd pray very hard to the Blessed Virgin, and the last minute something (good) always comes up. The kids that are born here and don't speak the language are trained by me. They always do a fantastic job. They say the words, but they don't know the meaning of the words, so I teach it to them. We never had an incident. One time the pull rope came loose so we had to drop the rope and lower the poles to the ground.

I'm very proud of the Altavillesi, because the immigrants of the late 1800s had no education; some barely knew how to sign their own name. But they came to this

country with one thing very special in their heart—the Blessed Mother. They carried on tradition here, and it still goes on after more than a hundred years. Officially, we were registered June 1900, with the State of Illinois. But the old timers tell me it goes back much earlier. Last year we had the Centennial, his Eminence Cardinal Francis George celebrated the mass. We also had the mayor of Altavilla, Dott. Salvatore Scaletta, Vice Mayor Salvatore Lobosco, the Assessor Salvatore Cirone, and two gentlemen from the Committee of the Festivities of our Blessed Mother in Altavilla, Pietro Rizzio, vice president of the Society in Altavilla, and Leonardo Petrancosta. The police on Sunday estimated between 25,000 and 30,000 people, coming and going. For the four-day festival, I would estimate about 35,000 people.

I'm proud to say that our feast in honor of the Blessed Mother in the religious aspect is not any different now that it was 60, 70, 100 years ago. The only thing is that in the old neighborhood, we had the church. Now we have (only) a temporary chapel with a tent, and there is (in Berwyn) open space, a big, huge, space. It's a parking lot at the rear of the Cermak Plaza, about 5 to 10 acres. Naturally, it doesn't have the effect of the closed-in neighborhood. As far as the traditions, the stands, the food, the entertainment, and the most important thing, the religious part, it's no different than it was in the old neighborhood.

Thousands of people come in, park the car, and walk to the back of the shopping center. The first thing they do is go directly to the Blessed Mother. They kneel, say their prayers, and thank the Blessed Mother for whatever favor they received, blessings, and then they socialize with their friends. They

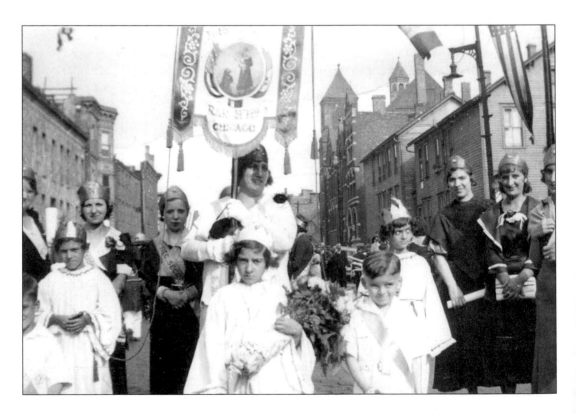

Women and children march in honor of Maria SS. Lauretana in the 1930s.

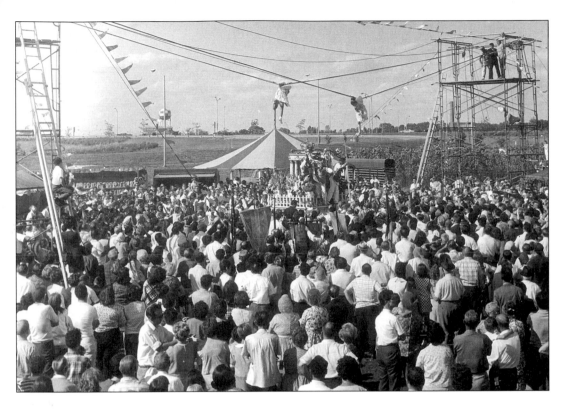

Mariella LoBosco and Anna Marie Calzatini perform the flight of the angels and recite prayers to the Blessed Mother at the 1966 Feast of Maria Santissima Lauretana. Joe Camarda sees the devotion of the Altavillesi to the Blessed Mother as the key to the success and happiness of his paesani group.

go have a sandwich, listen to the entertainment, and on Sunday they come in the morning for the torch procession, followed by the field Mass. In the afternoon, we have another procession including the traditional flight of the angels. Lighting candles is how people remember their loved ones. We get thousands of candles. Unfortunately we can't finish burning them all because we can't leave them burning overnight. It's against the fire code; the tent could burn up. A lot of people burn the candle there and when they are ready to go home, they take it with them and finish burning it at home.

The flight of the angels comes in during the procession. We go about 200 feet and then the first flight of the angels is done. Then we

continue with the procession. In the evening, we have the second flight of the angels.

Attendance is just about the same every year. For the most part, we figure that the Altavillesi in Chicago are more than double the population we got in Altavilla Milicia. That population is about 5,000, and with the second and third generation, we have about 10,000 here. The Feast of the Blessed Mother is followed by people from all the surrounding towns. People come down now from all of Italy as well as Italians that have immigrated to other countries. The feast in the Old Country always starts September 6, 7, and 8. Our church in my hometown is a sanctuary. There are tourists going there. We've got a lot of devoted people who received miracles there.

There was a young man, Mike Abbinanti. He

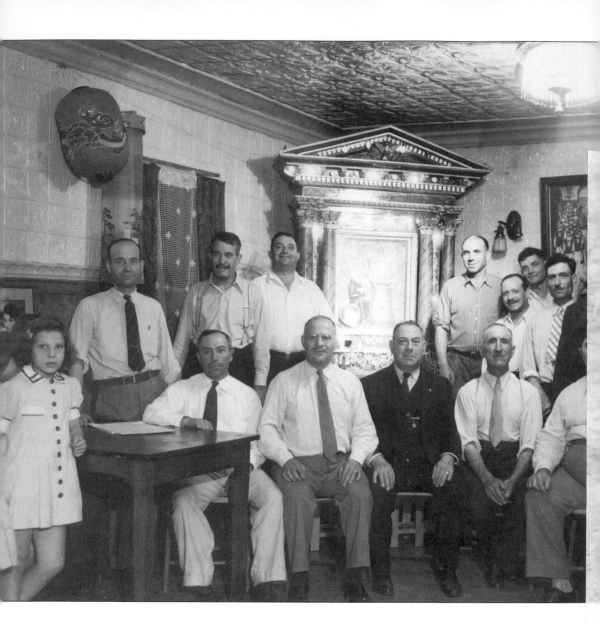

The Deputazione *members in the Maria Santissima Lauretana headquarters at 1027 Larabee Street pose in front of the icon of the Blessed Mother. From left to right are: (seated) Christ Chirchirillo, Michael Abbinanti, Mario Muscarello, and Francesco Stipati; (standing) May Giovenco, Joseph Giovenco, Frank and Paul Lombardo, and Michael Poladino. Note the tin ceiling,* c. *1930s.*

had to have a very serious operation, and he was kind of afraid, and I said, "Mike, be sure you take the picture of the Blessed Mother with you." He took the picture and put it in his hand. He went to the operation, and when he woke up the next morning, he had the picture of the Blessed Mother in his hand.

I witnessed back in 1956–57. The Blessed Mother was coming out of St. Philip Benizi Church and stopped right in front of the door where the angels say the first prayer. There was this young girl. Her mother was holding her, and she was a deaf/mute—she would never talk, she would never hear. The Blessed Mother came out of the church, and as soon as she saw the Blessed Mother, she turned around and said, "Mommy." In fact, there was a big article in the *Tribune* on that. I got the clipping. Do you know what her name was? Loretta. I have heard many, many stories like that.

In the constitution of our society, our forefathers sat down and they established this society. One of the things in there was that in the future, the congregation of Maria Santissima Lauretana would build a church to the Blessed Mother. But lay people can't build a church, especially if it's Catholic. As a matter of fact, in the middle '20s/early '30s, in the old neighborhood around Evergreen and Larabee Streets, was a community park (Evergreen Park). There was a church there, a small church of San Marcello. The officers of the society were going to try to buy it. The church (officials) got wind of it and said, "You can't do that." But they kept their society. They moved to the lodge hall, and they put the picture (icon) in there, and they made it look like a church. We would like to have a church of our own. I'd like to see it, but I don't know. Of course, there are a lot of things involved.

When we had to move from Larabee Street, we didn't have a place for a while. We rented a store on Montrose, near Damen Avenue, and we were looking. Eventually we bought this place where we are now on Lawrence Avenue (5845 West Lawrence). I said then, after we paid the mortgage on the building, we are going to make a chapel, and we did. The altar is a replica of the church (in Altavilla) in the Old Country.

We currently have about 400 members. What I like about our society is that it includes my kids, and they joined without being asked. You see there's a junior group of the Fratellanza, and the Sorellanza have an angel group, and they march with their mothers and fathers and carry on the tradition. One of the reasons why our society has been successful is that nobody is allowed in the society unless he is there for one purpose and one purpose only—the faith in the Blessed Mother. If you don't have faith in the Blessed Mother, you don't belong there.

We got a lot of help from Father Luigi Giambastiani when things were rough. Through our faith and the guidance of the Blessed Mother, along came Father Augusto Feccia. He did a lot with me to help us carry on the tradition. There were also (as spiritual advisors) Father Peter Gandolfi, Father Roberto Simionato, and now, God bless him, Father Gino Dal Piaz. He's been very helpful to us.

When Father Pierini had his dream about Villa Scalabrini, Father Luigi Giambastiani brought him to our society meeting. Maria Santissima Lauretana was the first society to support Father Pierini's cause. We were the first organization to donate a substantial amount to the cause.

The Milicioti are hardworking people. We have a lot of business people in our community. We got judges, doctors, lawyers, restaurant owners, banquet hall owners— Alta Villa Banquet Hall in Addison is even named after our town in the Old Country. We've got priests in our community also.

While I always admired and praised our ancestors, the founders of the Society, I take my hat off to the present generation, who followed the examples of our forefathers in carrying on this marvelous tradition with great devotion to the Blessed Mother under the title of "Maria Santissima Lauretana di Altavilla Milicia in Chicago."

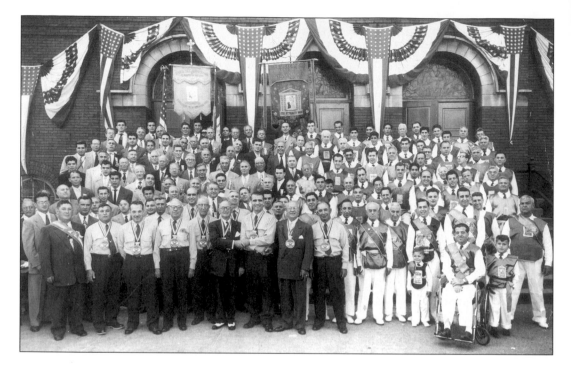

This is an early 1950s photo of the Deputazione *(left) and the* Fratellanza *(right) on the steps of the St. Philip's. Note the patriotic bunting, the American flag, and the cloth standards of the lodge.*

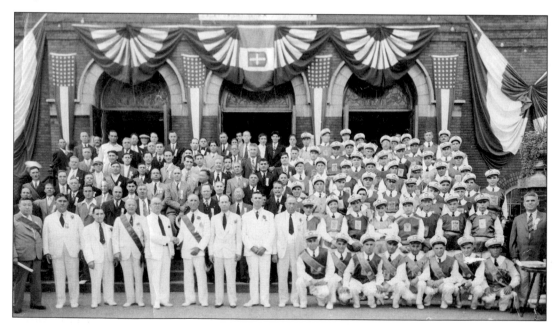

Pictured here is the 1930s Maria Santissima Lauretana Society. The officers are in white, the Deputazione *in suits, and the (younger)* Fratellaza *(brotherhood) are wearing vests.*

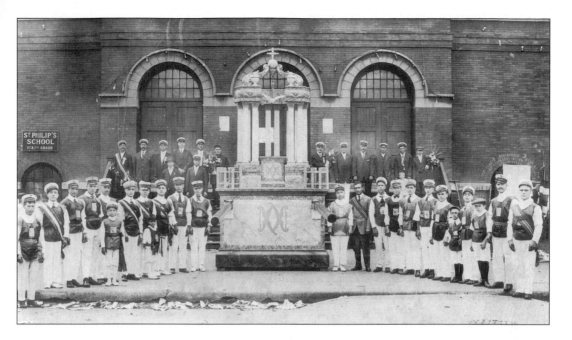

The Deputazione *and the* Fratellanza *(brotherhood), including some boys, posed with the heavy wooden* Vara *in the 1920s. Part of the devotion was dramatized by the community working together to carry the heavy burden. The design in front of the structure is the symbol of the Blessed Mother.*

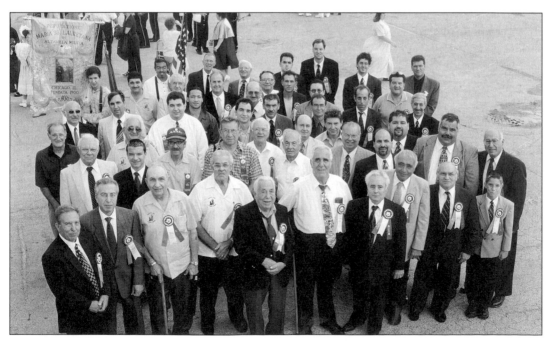

The Laureta Deputazione poses for pictures just as their ancestors have done for the past century.

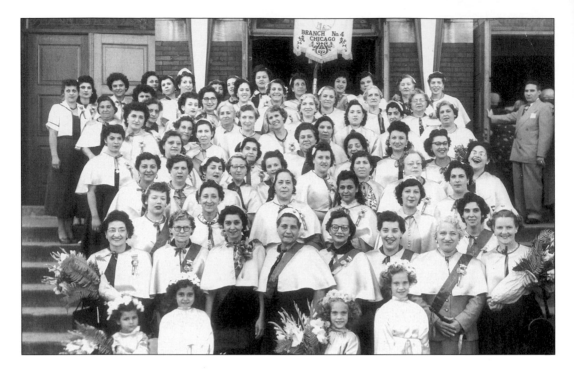

The Young Ladies Group Branch Number Four of the Maria SS Lauretana Society pose proudly with shawls, saches, flowers, and ribbons in the early 1950s.

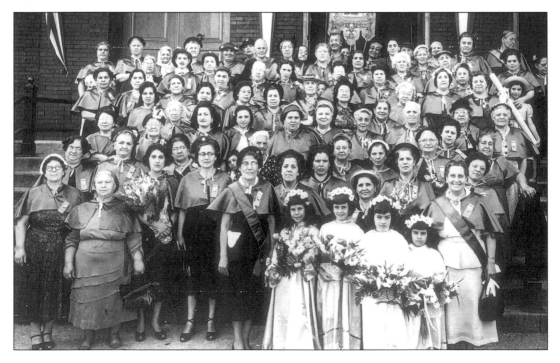

The Sorellanza (sisterhood) branch of the Lauretana Society is pictured in the early 1950s.

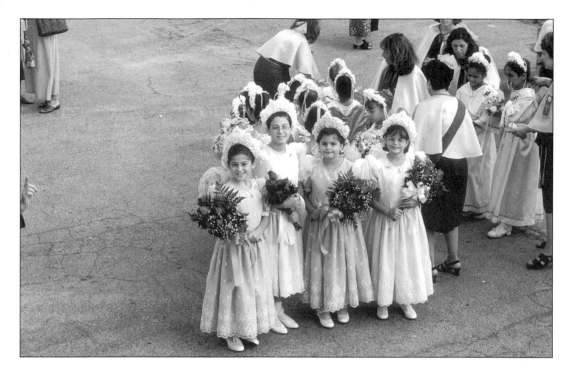

The Flying Angels have the responsibility both "to fly" and to recite the many-versed prayers to the Blessed Mother, 2000.

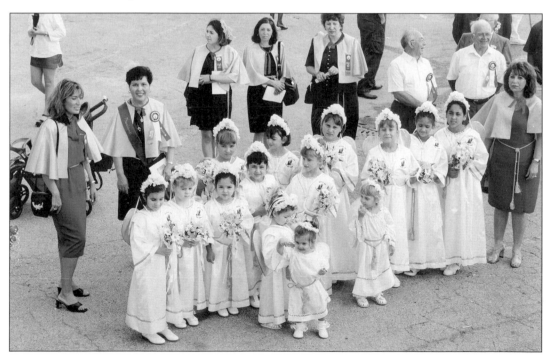

The "Walking Angels" are shown at the centennial Maria Santissima Lauretana celebration in 2000.

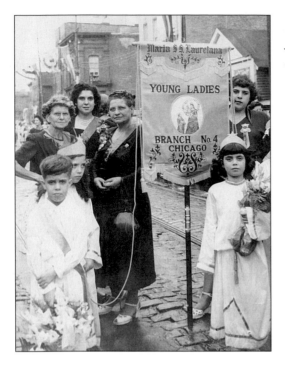

Altar boys, angel, and ladies are pictured on feast day in front of the standard of the young ladies. Note the flowers and badges worn by the women and the brick street and streetcar tracks, c. 1930s.

This wedding scene in the 1950s illustrates the appeal that St. Philip's had to Joe Camarda after he migrated from Altavilla to Chicago. He and countless other immigrants felt instantly at home when they saw that the placement of the icon of Maria Santissima Lauretana was almost exactly the same as it was in their church at home.

The Carro Triomfale of the Blessed Mother in the 1930s and 1940s had wheels and was pulled or motored through the street. Riding on the Carro are the club leaders, flags, a statue of Santa Rosalia, the Sicilian Band, and standing below, the Fratellanza, *awaiting the honor of propelling the icon through the streets of the Near North Side.*

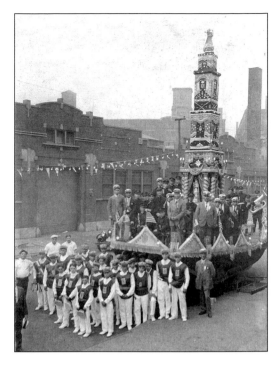

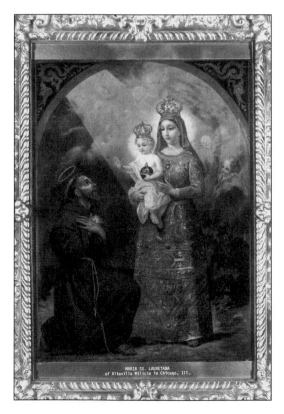

This is the devotional painting or icon of the Blessed Mother which tradition says washed upon the Sicilian shore and was transplanted by self-directed oxen to Altavilla Milicia in the 1400s.

Cardinal Francis George concelebrates the mass at the 100th anniversary of the Lauretana Feast in 2000. Shown at far right is Scalabrini Fr. Gino Dalpiaz, Director of the Italian Cultural Center.

Fr. Luigi Giambastiani bids goodbye at the last mass held in St. Philip Benizi Church on September 26, 1965. Giambastiani served the parish for over 50 years. The heart-breaking demise of this Sicilian church was precipitated by the construction of public housing and the resulting racial change in the neighborhood.

Club officers in the front row include Marco Muscarello and Christ Chirchirillo, and in the rear are Francesco Stipati, Anthony Cardella, and Thomas Stipati in front of the Lauretana lodge hall at 1027 North Larabee in the mid-1930s.

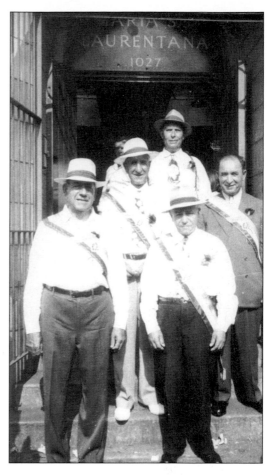

The electric light "illumination," typical of patron saint festivals in Sicily, was erected at the entrance of St. Philip Benizi at Oak and Cambridge in the 1920s.

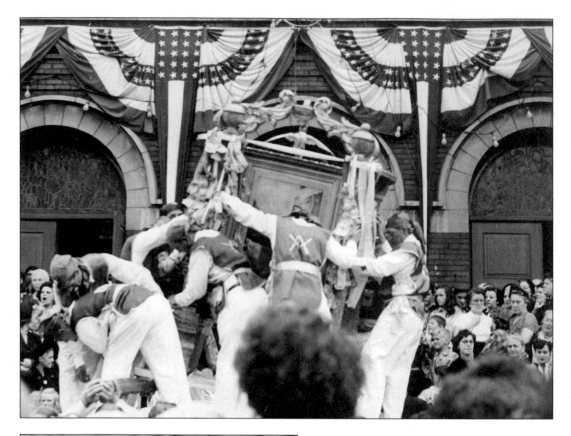

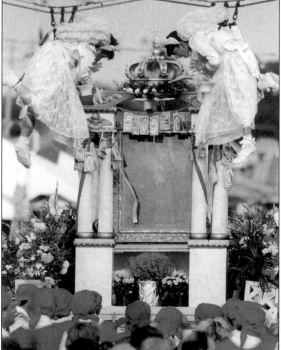

Members of the Fratellanza *maneuver the Vara as it emerges from St. Philip's for the street procession in the 1940s.*

In 1999, Lauren Pardun and Joanne Petrancosta represented the angels of the Annuziation and brought the crowd to attention with the traditional "Silenzio! Silenzio," and the recitation of the multi-versed prayer to the Blessed Mother.

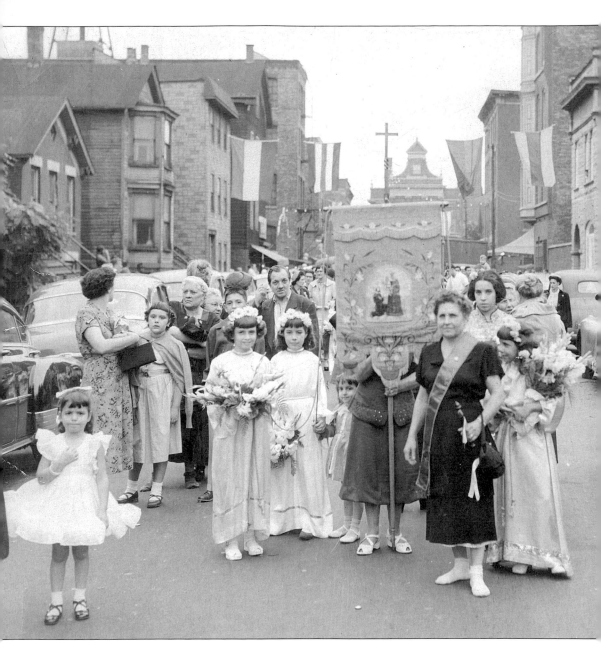

"Angels," parents, and Sorellanza *leaders display the banner of their section of the Maria SS. Lauretana Society,* c. *1940s.*

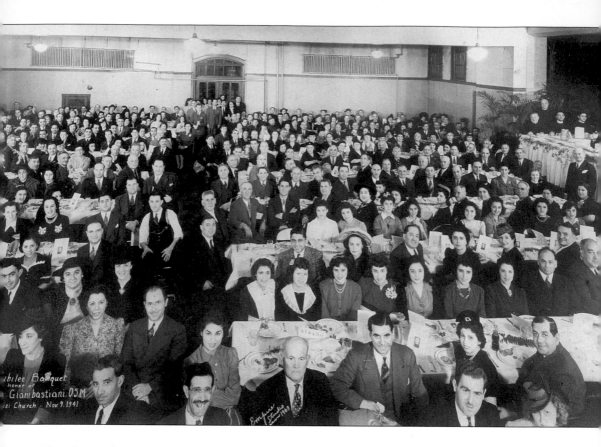

This dinner honoring Fr. Giambastiani's 25th anniversary as a priest in 1941 included many guests with origins in Altavilla.

ANTHONY SCARIANO

From Newsboy to Justice

"Don't Worry. I'll go sell oranges or grapefruit."

Appellate Court Justice Scariano had a distinguished record in his decade of service from the mid-1980s to the mid-1990s. In his retirement, he has become a columnist for the Fra Noi, *researching and writing about the origin of Italian surnames.*

Anthony Scariano is one of the most accomplished Italian Americans in Chicago, if not the whole nation. A close friend of the author, Scariano sat for a brilliant audio and videotaped interview in March 2001. This detailed narrative of his life up to 1950 is rich with references to the old Near North neighborhood, the Chicago Commons, and Italian Americans in World War II. He has a keen eye for detail and tells a touching story of a brief meeting with President Franklin Roosevelt. The narrative ends when the Scarianos moved to Park Forest, Illinois, in the late 1940s. Subsequently, Scariano had a brilliant career as an Illinois State Legislator, Racing Board President, lawyer, and Appellate Court Justice. His adventures in the OSS appear in Studs Terkel's *The Good War.*

MARCH 5

I was born on January 12, 1918, during Woodrow Wilson's administration, right in the middle of World War I, in the 1000 block of Sedgwick Street in Chicago, where the Cabrini Green homes are now. That whole neighborhood was Italian, predominantly Sicilian. They tore down that whole neighborhood to build the Cabrini Green homes. My father came from Villafranca Sicula, Provincia di Agrigento, in Sicily. My mother came from Provincia Palermo, Altavilla Milicia, where Maria Santissima Lauretana is the patron saint. They married in Chicago. At that time, they were living on Cambridge near the St. Phillip Benizi Church, where Father Luigi Giambastiani was the pastor for over 50 years. He married my mother and father and baptized all of us kids.

Grandma and Grandpa were married in Italy, though. They came shortly before the First World War. My dad came when he was 17—he was born in 1896, so he came in 1913 or 1914. I frankly think that he and his brother came here to avoid military service in Italy. There is a colony of Sicilians in Chicago, from both places. Mom was three when she came; she was born in 1898, so in about 1901, she got here a little before dad. They married in 1914, when she was about 15 and 10 months.

My mother went to the Jenner School. When she was a bit older than three, Grandma (and my mother) for some reason went back to Altavilla for a short time. Mom came back when she was 11. She went back to Jenner School, but not for too long, because Grandma was working in a tailor shop where she'd take work home. She would take a bundle of men's trousers, and she was sewing belt loops and flys on these pants—they didn't have zippers. Mom worked with Grandma at home. She couldn't have been more than 12 or 13. I don't think she (Mom) got much beyond the fifth grade. All of her letters in Italian to the Old Country were written in the Sicilian dialect.

They spoke exclusively the Sicilian dialect—way different than the Italian. If I spoke Sicilian to you, you wouldn't understand very much of it; although some of the words are similar to southern Italian, very similar to the Calabrian. My grandmother was absolutely illiterate—absolutely. She didn't speak Italian, she didn't speak English, and she didn't even speak Chicago Italian. She spoke only the Sicilian dialect. She died in the '60s—she was in her 80s. She not only did not learn (English), she didn't have to learn because in the neighborhood, all you would hear was Sicilian. Everybody who did business in the neighborhood was Sicilian. The professional people were Sicilian. The only professional people who were not Italian were our public school teachers. Italians in that profession were scarce. It's a different story today. Indeed, we now have an Italian-American School Superintendents Association.

John, my brother, was the oldest, he is now 85. I'm 83, the third child; Marie is five years younger, 78; and Joe is 73. My father was a butcher—he spent time in Johnson

City, Illinois. There was a colony of his *paesani* there, and he did candy factory work for a while. But when he died in 1928, I was 10, he was 42. He was working for a tailor shop—men's suits—Alfred Decker and Cohn, now a part of Hartmax. But he had a very boring job; it was an assembly line job. He pressed sleeves—only sleeves on coats, jackets. Mom did home work. She brought home baseballs to stitch. They were cheap baseballs. They weren't American League, or National League, or even Minor League. Those were softer, and they were easier to stitch. We used to help her sometimes, when we caught on to it with the needle and the red thread, red twine. She sewed lamp shades too. She brought lamp shades home—sewed them by hand. [The pay was] a pittance. It was an absolute pittance—not much at all. We'd go with her to pick up the material—the baseballs, lamp shades, the material that went into lamp shades.

The Sicilian dialect was spoken quite a bit at home. . . . [our parents] picked up a lot of English from us. We picked up a little bit of Sicilian from them. . . not much. The Sicilian I really picked up from Grandma after my father died. I was 10. . . . the apartment we had when dad was living we called a flat; we never heard the word apartment. The flat was the second story of a frame house. Upstairs on the third floor was the landlord and his family, and down below, another tenant. It was below the street, but you had to come down the steps into a yard into the first floor flat, which was really a basement flat. We had two bedrooms, a kitchen, and a living room. The bathroom had only a toilet. We didn't have a sink in there, we didn't have a bathtub. But it was indoors; in Italy, you had to go outside.

I remember very well the school I went to when Dad died. It was the Schiller School. The neighborhood we were in used to be a German neighborhood, but it became Italian. When the Italians moved in, the Germans moved out. When I lived on Peoria Street, the Scandinavians moved out when the Italians moved in. That's the story of our lives.

You could smell the Italian food—the familiar fragrance of eggplant frying; I love eggplant sandwiches. Fry eggplant or broil it and put it between a couple of slices of good Italian bread and make a meal of it. That's all I need. You could smell spaghetti sauce cooking. The smells of the grocery stores—everything was out in barrels—a barrel of coffee—the barrel wasn't full, it was a false bottom, and the coffee would be piled up high in the barrel—crackers, biscotti, rice, and then pasta, like the mostaciolli, the tubetti. It wasn't packaged, no, it was weighed and wrapped, and so were pickles, and olives, and everything Italian. Sometimes in front of the store—the fruit was in front of the store, apples, oranges, pears, berries, cherries. And chickens; the grocery store didn't have them, the butcher did. The chickens were in big crates where they couldn't get out. The butcher would take one out of the crate and wring its neck, and you brought it home, or you brought it home live, and grandma would wring the neck. You got the wringing for nothing. Grandma used to put the chicken in a boiling pot because it was easier to pluck its feathers. We had a couple of chickens and even a goat in the empty lot right next door to us when we were living with Grandma. My father would never have had any of that.

Pop was suffering, we know now that it was depression, but nobody had ever heard of depression in the *clinical* sense at that time. You could be mildly depressed over some traumatic event or some sadness in the family, but it wouldn't last forever. He went from doctor to doctor; he'd tell them how it felt. They'd take tests and they'd never find anything wrong. He was healthy from a clinical standpoint, but emotionally he was a very sick man.

One day in 1928, we, all us kids, came home from school—November 2, All Souls Day. My grandmother took heavy note that it was All Soul's Day. My father was not a churchgoer, and she concluded that had something to do

Candy factory workers outside of Bunte Brothers Candy Company in 1929 include Gilda Dentino. Like these women, Scariano's mother worked long, hard days in a candy factory.

with it—all rather folklorish. There he was hanging from a door jam to the master bedroom, and he was hanging there on a rope, and his face was black and blue. It was a horrific sight. My little brother discovered it. He got out of kindergarten a little bit sooner than we did. In 1928, he was five years old. So when we came to the house, apparently some people had gathered and the police had been called, because my brother Joe, who was the five-year-old, came running to us and he said, "Papa's sleeping on a rope." That's how he figured it. "Papa's sleeping on a rope." We didn't know what he meant until we saw this, this terrible sight. Stresses that had to do with immigration? I think so; he was laid off. Doctors couldn't find anything, and that

depressed him even more because he knew he was sick. He felt it. [If he had never immigrated, do you think this would have happened?] maybe not, but it might run in the family because I got depressed just as World War II ended, and it was a clinical depression. It's hard to say that he would have had it if he had stayed in the Old Country.

We went to live with Grandma after the funeral. We hardly had insurance money enough to bury him. Grandpa worked on the railroad. He was an outside laborer for the Chicago, Milwaukee, St. Paul Railroad laying ties and rails and keeping them in good condition. We went to school, she [Grandma] had lunch for us, and Mom would come home after 4:00, because her workday was 8:00 to 4:00. As a matter of fact, she was working while dad was sick. . . in a candy factory. It was close enough on Orleans and Superior to the neighborhood that she could walk there. We lived in a flat in my grandmother's building, fourth floor rear. In grammar school I did very well; in high school I didn't do too well. I went there because my friends were there. I took the two-year electric course at Lane Tech. The main building was on Sedgwick and Division, which is near the old neighborhood. This was a branch of Lane Tech on Cedar and State. It was an old red brick building that was built during the Civil War. I went to school there, beginning in 1931. It was all vocational, electrical work, and manual training.

I wanted to be with the boys that I was with in grammar school and in the Chicago Commons Settlement House. I spent two years at Sheldon Branch, and through a friend of mine I learned that you could work after school at a newsstand in the Merchandise Mart. We had newsstands made of metal, and they could be wheeled, and we would wheel it through that long corridor. I had the stand in the lobby, and there was a stand at the end on Orleans Street. The main stand was the cubbyhole of a store that was on the Wells Street entrance. We had a stand upstairs near

the El station on Wells. We were all Italian boys who had the after school jobs. I suppose that the first boy who had the job was Italian— Gianlombardo. It was only about a 15–20-minutes walk from the house. We got 50¢ a day, $3 a week. We worked Saturdays also because in those days people worked at least a half-day on Saturday. That was enough to pay for milk and a few other groceries. My mother made, oh. . . $12–13 a week. By that time, we had a Fair Labor Standards Act, and she was guaranteed a minimum wage of 25¢ per hour, but her company paid 35¢.

I was there all the way through high school. We went to the Commons after school if we weren't working, but we did go on Saturdays if we didn't have chores to do around the house, and ordinarily we did. But we could go evenings after we came home and had dinner. We'd go to the Commons for movies, for wood shop, for art, for gym, athletics from 6:30 or 7:00 to about 9:00. We liked it very much.

I dropped out of high school between my sophomore and junior years when I was 15, because a full-time job opened up, and full-time jobs as well as part-time jobs were very scarce in those days. I'm talking about 1933 now, the first year of the Chicago World's Fair—Century of Progress.

The Commons was a place we went for evenings, and the fellow who had the full-time job on the stand on the Wells Street entrance of the Merchandise Mart got a job in Marshall Field because Marshall Field was big in the Merchandise Mart. They sold wholesale practically all of their products—Martex, their brand names. He got a full-time job, Al did. And that opened up his job—paying $9 a week, which was big money in those days. I took it. [What did your mother say when you told her you were going to quit school?] She didn't mind it at all. I was 16; I wasn't under compulsory attendance anymore, and $9 a week added nicely to what she was making and helped the family. I did about a year and a half of working full time in that position—I should say job, and I took care of the store.

After a year and a half, I asked for a raise and I was refused, and I was told that I was lucky to have the job. That made me mad, and my independence demonstrated itself. I took my smock off, I rolled it up, and I threw it in the boss' face and I said, "You know what you can do with your job!!" And I went home, and I got home about 5:00, and Mom says "How come you're home so soon?" (The job started from about 7:00 in the morning 'til 8:00 at night, because I had book work to do, accounting). I said, "I quit my job," and she said "you what?" I said, "Don't worry, I'll go sell oranges or grapefruit."

I had about $4 or $5 saved up, and that was capital, so I took the money to the Randolph Street Produce Market. From Peoria and Grand, it is only about four or five blocks to Randolph Street. I'd buy a case of oranges or a case of grapefruit. My uncles, who were in the fruit business, helped me buy them. They could tell good fruit. I worked summers on the fruit wagon with them, and sometimes on Saturdays I bought a case of oranges, lugged it on my back, put it on the back end of a street car, paid my 7¢ fare, went to the end of the line, and went door-to-door selling oranges or grapefruit, berries, sweet corn, whatever was in season. I'd peddle from the end of the line on Elston north and northwest to the upper middle class neighborhoods. Sometimes I'd get through around lunchtime, sometimes a little later, and sometimes around dinnertime.

I went back to school because it was a hard life, and the Commons was influential in that respect. The counselors had adult education, and I was classified as an adult because I was 16–17 and out of school. We would read books, read *The Nation* and *The New Republic*, which were rather liberal magazines, and the *Literary Digest, The Atlantic, Harper's*, which I sold and sometimes I'd read when business was dull at the store. The Commons had me in a typing class. The WPA sponsored a typing class where I learned to type, and it stands

me in good stead now with the computers. And I was training for a stenographic job. I began to think, I began to write sports stories, news stories. I ran the newspaper in the Chicago Commons all by myself. I went out and got the news, I typed it, I'd cut the stencil on the mimeograph, and I ran it off. I put it together, and I distributed it all over the neighborhood. And I said, "This is a lot of fun. I went to the library to get explanations on how to become self educated, what books to read—a sort of Great Books Program—and I did that at the Commons. Arch Ward was the Sport Editor of *The Tribune,* and he came to speak to the boys at the Commons. We kids were interested in sports, in the All Star games. Ward started them and the Golden Gloves. I would write stories about them, and when he came to speak, I had my stories with me. And the social worker said, "Our young Tony here wants to show you some of his work done on the typewriter at home following baseball on the radio." He looked at them and said that I had a nice way with words. He was very encouraging, and I said, "I'm going to be a journalist." And I tried to get a job as a copy boy or something. No jobs available. Hal Totten was a radio broadcaster at the time. He used to broadcast the games and Bob Elson. I'd write to them saying, "I want a job. I'll be your copy boy." Naturally, I was interested in the games too! They didn't have any jobs. Then I said, "Baloney on this. Where will I be next year or five years from now?" And I said to Mom, "Mom, I'm going to go back to school." And she says, "Okay, but you can't expect any help from me."

So I went back to school, and the teachers greeted me like the prodigal son. They fixed up a schedule where I could get out by 1:00 or 1:30, walk to the Merchandise Mart (I got my old newsstand job back because there was a new boss there). They were looking for a guy, and I said, "I'm your guy." I went to school. I started work at 3:00, got there about 2:30, got my stand ready, fixed it up, wheeled it out about 3:00, and people would start leaving

3–3:30 and 4–4:30—big rush hours. People going for a streetcar or the El. After that (6:00 p.m.), I ran to Milwaukee and Ashland to sell shoes, women's shoes, at Feltmore and Kern. You could buy shoes for $3.33. . . . And I was typing for the school paper in a National Youth Administration job for $5 a month. I made more money on these three jobs than I was making on a full-time job. Teachers fixed me up with a scholarship and a job in Jacksonville to go to Illinois College, a job in the school for the blind. I wanted college prep with English, book reports. I wanted theme writing—math I didn't care too much for, although in algebra I was pretty good, but in geometry I made a "g."

So a teacher who went to Illinois College said, "I can get you a scholarship—You've got the ingredients." That is, I qualified for a needy scholarship—my grades weren't that good that I could get a scholarship on grades. So she got me a scholarship, and I went to Illinois College, and I got the job at the Illinois School for the Blind, feeding blind kids—a rather unpleasant job. These kids couldn't use silverware. I used to help them eat. They'd eat with their fingers, and our job was to train them in using silverware as best as they could. That was it. I went to college for one year there.

I advanced to the University of Illinois the next year because I got a legislative scholarship from the state rep in my neighborhood. [Were you aware of Democratic politics?] Very much so. I went to the state rep, and I told him, "Look, I've got 15 votes in my family alone. I'll work elections." So I worked as precinct captain, even though I wasn't old enough to vote, and he gave me a state scholarship. A college professor that I had at Illinois College in Jacksonville was writing to me when I was at the University of Illinois, and he says come out here. "This is the place to go to school— Washington, D.C." He was working for the RFC (Reconstruction Finance Corporation) making $120 a month, and he was a little bit more than a file clerk, because he wanted to

go to law school. He started George Washington Law School while supporting a wife and family. He wrote, "This is the place to go. Get yourself a job; get yourself out here, and stay with us. It won't cost you anything unless you get a job." I got a job in two weeks. I camped on a senator's doorstep for two weeks. He couldn't get in or out of the office for two weeks without stepping over me. Finally he called me into the office and said, "What can I do for you?" I said, "I need a job. I got two more years of college. I want to go to college. My father died when I was 10, just like your father did." Because I had read about him, I said, "You took in washing for your mother; you went with a coaster wagon and picked up laundry from your neighbors for your mother to wash. I can't go to school unless I've got a job, and you've got to help me find a job" This guy wasn't crying, but his eyes were glistening when I told him how he helped his mother when his father died, and that my father died and that my mother worked in a candy factory. I told him the whole story being raised by Grandma.

James N. Slattery—he took Harris Lewis' place. Lucas gave me a job later, when Slattery lost. I was taken over by Senator Scott W. Lucas. I was a Capitol cop. At 4:30 p.m., the Capitol closed. You made a tour of the doors on your side of the Capitol or the House Office Building and saw that everybody was out of the building. The rest of the time, you could study—from 6:00 to 7:00, close to half the time. . . There you have the story of how I went to college. You know how much I was making? More than the college professor—$135 a month. I was sending money home.

I went to George Washington University. This was September `39. I got my degree in 1942. It took me three years because I couldn't take a full schedule if I was working eight hours a day. Those years in Washington were very interesting because Lend-Lease came up, the Destroyer Deal with England, and the draft were hot issues. I went to

school in the morning, and in the afternoon I volunteered in the senator's office (you had to contribute your time to the senator, because he got you the job and that was the payoff). We were being flooded with mail at the time. . . I was very politically inclined (aware). The senator's office was highly educational—most instructive because you learned which women in the office (they were all women) handled immigration, which handled agriculture jobs, post office, constituent requests, and how they did it. Gradually I learned to do constituent problems myself, went to the departments and met with people, asking them to help us resolve problems for our constituents.

There was not much [Italian connection in this period]. There were Italian families that I visited for a good Italian meal every once in awhile, but they didn't have any good Italian restaurants in Washington at the time.

I saw FDR. When he came to the Capitol, we had to stand guard in the rotunda. He had to come through the rotunda, and one time he asked me if he could smoke in the rotunda. "By all means Mr. President, you're the boss," I told him. I was there when he declared war—in the gallery, and that's when he asked me if he could smoke. We kind of followed him around. We used to see him. He would be sitting in the back seat of a limo. The chauffeur would come out, or a butler, and flip up his legs. You could hear them snap. And then they'd stand him up and put him back in the wheelchair, and wheel him through the rotunda, and bring him up on the elevator, and wheel him into the House. Nobody could see that, him getting off at the door standing up, his legs straight and holding on to his son, his aide.

In 1939, a couple of months after I started work there, Leah had a roommate who was the girlfriend of one of our sergeants, John Herrich. Leah needed an Italian teacher. She was preparing for a career in the Foreign Service. She was already taking French and Spanish at George Washington—night courses—and her congressman was a big

Scariano worked his way through college as a Capitol policeman. In this 1939 photo,

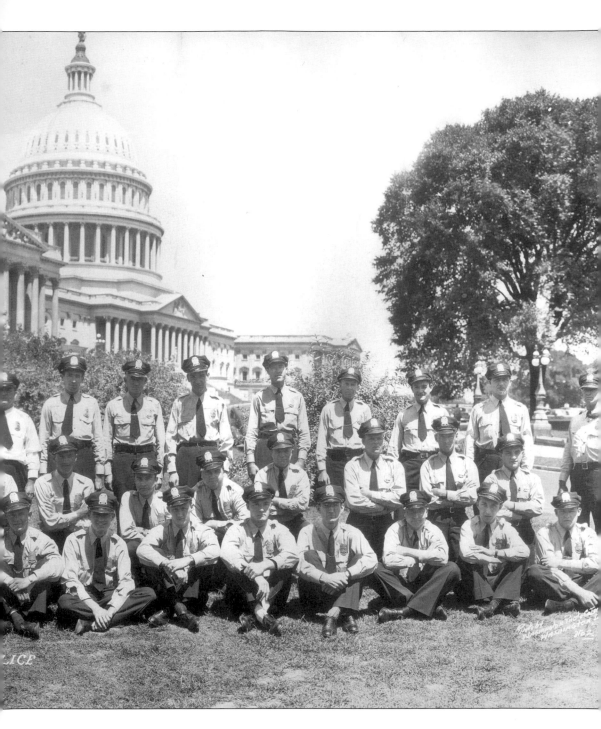

Scariano is the fourth from the left, standing.

power. . . Edward Taylor from Colorado. He was chairman of the Appropriations Committee! He served with Hull La Guardia, all the big shots who were not in the Congress anymore. . . He was in there 30 years when he died in 1941. She wanted to take Italian. . . but at her own speed. . . and she asked him, (the sergeant), "Do you know anybody who can teach me Italian?" He said, "We've got two Italian boys on the force and I'll see."

We met on Columbus Day, 1939. Just before I went into the service, Leah went to Mexico and Guatemala in the Foreign Service as a Code Clerk. We were at war by this time, 1941–42, and she was home from Guatemala for Christmas in 1942. I was on furlough from Camp Lee, Virginia.

I went to meet her in Glenwood Springs, Colorado. And I said "Look, we've been postponing getting married—I wanted to get through school; I'm through school. . . now

Young Tony and Leah are shown on a stroll near the Capitol at cherry blossom time in 1939.

we got the Army. When I come back (IF I come back), I've got law school. Then I've got to put it off because I'll just be getting a job, and this is going to take us until we are in our seventies. Let's get married!" She said, "You're right. Let's go!" She straightened things out in Guatemala; she came back and got a job in the War Department taking notes at General Marshall's press conferences.

The wedding. . . Fort Knox. . . The company commander knew that I was getting married. Some of my friends in the Army stood proxy for best man and ushers, and we were married in Chapel 92 by Father Thomas Francis Keane. She had a bridal veil and gown. My mother came, her mother came, her cousin had a boyfriend at Fort Knox, and she came from Terra Haute, Indiana. Afterwards, the wedding party and the priest went to Luisi's in Louisville, which is only about 15 miles away. We had 12 for the wedding dinner. Do you know how much it cost? Ten dollars—for 12 people!

When I went over I was AMG military government officer. Because of my Italian, they sent me overseas. I was anxious for action. In 1943 I was 25. My immediate superior was a guy who taught classics at John Hopkins. I was teaching Italian in North Africa, and we were waiting for Rome to be taken. We had Anzio, we had Salerno, but we didn't have Rome, and I was slated to be military governor of Reggio Emilia in the Po Valley. The former classics professor said, "You want action? I'll see if I can find something. I was in the hospital with the flu. He said, "Here are your orders. I don't know where you're going or what you'll be doing, but an outfit known as 'OSS,' they want you in Corsica. Are you ready?" He said, "Here are your orders." I said, "The orders don't tell me anything." He said, "You'll find out when you get there." And I did. I was with the OSS. They had islands in the Tuscan Archipelago Capraia and Gorgona, which is mentioned in Dante's *Inferno* .

This was the end of `43. In the airport, an American civilian came to greet me. His

Among those completing officer training at Fort Knox in 1943 is Anthony Scariano, second from the right in the third row. Scariano's military career took him to Italy with the OSS.

name was Nelson. When I mentioned OSS in the airport, he said, "Shhh!" I said that they mention it in the newspapers. And he said, "Yeah, but they don't mention it in Corsica." I did allied military government work. I fed the civilians, and I kept them out of the hair of the military. These two islands were penal colonies, and there were colonies of Italians who took care of the work in the prison—guards, cooks, janitors, everything. [There were] about 300 to 500 on each island, and my job was to keep order and keep them fed. I didn't do anything. I turned it over to the civilians. Instead, I began to do OSS work. They said, "This is the kind of work we do, and we need another man here." I transferred into the OSS, and I didn't stay long as a military government officer anywhere. I finally was an intelligence officer

and assistant operations officer of OSS, and I went out on operations. I did strictly OSS work.

At the end of the war, we had teams all over Northern Italy. Our base was Florence, and we were looking for a place in Bologna to establish our headquarters. The end of the war came, April 25, 1945, *venti cinque aprile quranta cinque*, now a national holiday in Italy

When I went overseas, Leah went back home, and she worked in the naval hospital in Glenwood Springs. They took over the Colorado Hotel and the swimming pool, hot sulfur spring, and used it for hydrotherapy for wounded naval personnel.

I got out in late '45. I had the points to get out early. I had four battle stars, so I got out pretty early. I had my job back (in

Pictured are some of the Italian American legal establishment, including Rocco De Stefano (pen in hand) that Scariano shied away from when he decided to establish himself in Park Forest. From left to right are: (seated) Horatio Tocco, Judge Francis Borrelli, Judge Francis Allegretti, Judge John J. Lupe, Judge John A. Sharbaro, Rocco DeStefano, Joseph Orrico; (standing) Henry Tufo Anthony Champagne, John De Grazia, John B. Meccia, William Parrillo, George Spatuzza, Donald Rizzo, Anthony T. Clemente, Lawrence Marino, Paul Comito, Anthony Caliendo, George L. Quilici, Vincent Chisesi, Frank Loverde, and Joseph A. Sambreno, c. 1931.

Chef Tony serves up spaghetti in his Park Forest home in the early 1950s. Among the founding fathers of Park Forest, Scariano was elected to the state legislature in the late 1950s.

Washington) in the senator's office. . . full time for the Senator, Scott W. Lucas. . . I went to law school. We had an apartment—defense housing. Law school took me two and half years using the GI Bill. Shortly before I graduated, the senator asked me, "What are you going to do when you graduate?" I said, "I'm going to go back." He said, "What do you expect? That people will beat a path to your door as soon as you have your shingle up?" I said, "No, but I think you can help me." "He said," I can help you here. Are you interested in labor law? How about the NLRB? Anti-Trust?" I said, "I don't want to stay in Washington." He said, "What do you want to do?" I said, "Maybe you can help me into the U.S. Attorney's office. To be an assistant U.S. attorney." "I think I can help you. " He said, "I made his father a Court of Appeals judge, and I appointed his son the U.S. Attorney who is in there now."

We went directly to Park Forest. Phil Klutznick had an office in Washington, and we read the article in *Collier's* about the "Dream City for Veterans." It was being built; it wasn't even open. I said, "Hey! A place where you can start your own government from scratch! No child will have to cross a main thoroughfare to get to school. It's built for kids." We did a lot of business with Klutznick through the Federal Housing Administration, and I called them up. I heard it was going to be pretty hard getting into Park Forest. They were screening people there because the demand for housing was so great! We were the 35th family.

Our old neighborhood (in Chicago) was going to be taken over shortly. I didn't want to go back to the old neighborhood anyway. What kind of law practice could I have in the old neighborhood? First of all, we had enough lawyers in the neighborhood. Rocco De Stefano, Joe Caracci (were established), and it would have been hard starting. I wanted to go where I could build my own practice. I was going to go and be an assistant U.S. Attorney. . . I said, "Can I moonlight?" The answer was, "You not only *can* moonlight, you're going to *have to* moonlight on the salary you're going to get." You know what the salary was? $2,900 a year.

My father had *paesani* here (Chicago Heights). He knew the whole Bullaro family and the Di Giovanni family. We were at a wedding here when I was a kid. As far as Italians were concerned, I knew that there was a heavy Italian population here, and that was good enough for me. I didn't need the old neighborhood. I gave myself no more than four years in the U.S. Attorney's office, where I could pick up everything they had as experience, and I did—you couldn't pay to get that kind of an education. I figured, "O.K., I'll moonlight in a small town that I was growing up with." Henry Dietch and I, you remember the tire store on Illinois and Oak? We were on the second floor. I made almost as much moonlighting that year. I made $2,000—total of $4,900.

Judge Otto Kerner, (later governor of Illinois) swears in Anthony Scariano as an assistant U.S. attorney in 1949. Scariano was appointed to the post after completing law school at George Washington University in Washington, D.C.

Umberto La Morticella

The Self-Taught Teacher

"As far back as I can remember, my greatest desire was to want to know."

The Otto House, an industrial boarding house, was located on 22nd Street near Inland Steel and the La Morticella house. By the 1940s, it had become somewhat run down.

Umberto "Albert" La Morticella made his living as an insurance man, but he had an intellect that knew few boundaries. Coming of age in the 1930s, when formal higher education was inaccessible to him, La Morticella's true passion was Italian language and literature. This segment did not originate as an oral history interview but as a series of letters to his son, Nino, as a birthday present. What appears below is a condensation of a piece that appeared in *La Parola del Popolo* in the early 1980s, edited by the author.

UMBERTO LA MORTICELLA

Well, at that time Chicago Heights was similar to one of the western towns one sees in the old western cowboy movies. The streets were unpaved; 22nd Street had 26 saloons. Card playing, booze drinking, and pool shooting were the only recreation these foreigners would have. Everything was horse-drawn. When 22nd Street became paved with cobblestones, the curbs had iron rings imbedded in them to allow horses to be strapped and parked there.

Men used to sport around with revolvers in their hip pockets. The neighborhood was a little rough for wives and girls to be around. However, whoever had a daughter would have her serve in his saloon to attract the young men. For every girl, there were many suitors at that time.

Nonno was born in Sulmona, but the family moved to Castel di Sangro when *Nonno* was a little boy. . . Chicago Heights at that time was host to many Castellani. . . Illiteracy was high among them, and those that claimed to be literate possessed a literacy that was hardly functional. They were a fertile ground for swindlers, con men, and astute politicians. They were honest people, very trusting, very naïve, and easy targets for victimization. They worked under brutalizing conditions. Chicago Heights had steel mills, chemical factories, very dusty woodworking factories, etc. Every place was a place of heat, grime, dirt, dust, stench, harsh glares, overtime, piecework, pollution, no safety gadgets, sweat, etc. The workers were, as the Italians called them, *"Bestie da Soma"*— beasts of burden. Emphysema, stomach ailments, heart ailments, and booze drinking to make the harsh conditions tolerable were what could be expected from such a context. Many men became morose and intolerant toward their wives. They yelled at them, beat them up at the least provocation, and were cruel and indifferent to their children.

As far back as I can remember, my greatest desire was to want to know. What attracted me the most was a book. I read my first and second grade books over and over until I knew them by heart.

I spoke Italian at home all the time. When I was 10 years old (1916), I understood everything. Of course, it was the *Sulmontino* dialect, but I managed to get by with other dialects, too.

Chicago Heights had a goodly number of Socialists and Anarchists. At that time, they were the only ones who were literate and articulate, because they were the only ones who read. They managed to invite the publisher of a weekly paper, *"Il Martello,"* Carlo Tresca from New York [1917]. By the way, he was born in Sulmona, too. He was to speak in a hall that was attached to a saloon. It had a seating capacity of about 200 persons. In order to get into the hall, one had to enter the saloon and then go through a door that led to the hall. The city hall became aware of the meeting, and so dispatched four policemen to this meeting place. The police placed two chairs on each side of the entrance. In order to get into the hall, one had to pass between the policemen. One of the cops was Italian; he knew every resident of the Hill by his first name. The confirmed radicals and myself (11 years old) didn't give a damn about the police, and went right through. Many people came with the intent to be at the meeting but cowered at the sight of the police. The

Workmen at Inland Steel in Chicago Heights guide a molten steel rod as it emerges from the machine. As La Morticella explains, work was tough, and the conditions in the plant were both unsafe and unhealthy.

attendance at the meeting was very small. Tresca began his speech quoting Machiavelli—*"Il popolo ha il governo che si merita."* (The people have the government that they deserve.)

Wherever Italians were involved—New Jersey, Pennsylvania, Ohio—there was Tresca speaking to them in their language. I might say he was the counterpart of Che Guevara. One day, in broad daylight, he was gunned down by unknown persons, according to the daily press. . . .

One day when I was a junior in high school (1922), my mother was watching me do my school work, and with a certain innate pride, she said, "I wonder what you will be doing when you are a grown man." I answered, "There's time yet to think about it. I'll have to go to school for five years yet." Upon hearing me say, "Five years yet," my father

sprang up from his chair, screaming at me, "What the hell do you mean *five years*? You better go to work. What the hell do you think I am, Roccofalo?" He meant Rockefeller.

That night, I went to bed, and all night long I was haunted by the words, *"five more years, Roccofalo, You better go to work. . . ."*

I tried going to bed very early and getting up at two or three in the morning to do my schoolwork. That didn't work, because I was sleepy and tired the following day. Finally, one day I walked across the street from my house and talked to the man who was foreman at the Inland Steel Company. I asked him for a job. Two days later, I was hired. And so, I, too, began tasting America in the raw.

Well, what kind of a childhood did I have? We did the same things that children do today, only our amusements and recreation did not at all indicate affluence. We did not

The La Morticellas are shown in 1971 at Saint Ann's Church in Chicago Heights on the day their grandson Mateo was baptized.

go to the beach. We went to the swimming hole, where no girls were allowed because nobody had a swimming suit. . . . We didn't need a ball to play ball. Half of an empty salt sack or a Bull Durham sack stuffed with rags and sewed into what looked like a ball and a heavy broom would do if we didn't have a bat. I had a set of rocks that were smooth and roundish, and with them we played bocce.

During the summertime, at age 10–13 (1910–19), I worked on the onion farms picking onion sets. At age 14 and 15, I worked on the belt at the brickyard—during the summer months, of course. It was hard work. The rule was that 16 was the minimum age for that kind of work. When the business agent came around, I would be warned to go and hide, or I would lose my job. As soon as he left, I would be called back. The brickyard was rather primitive—the bricks were dried

in the sun before forming kilns and heating them.

At age 17 (1923), I became a full-fledged, full-time worker at Inland Steel Company. I remember the first night of work. I started 6:30 p.m. and quit 6:00 in the morning. I worked on the straightening machines. It was 11.5 hours of deafening noise. The bars going through the straightening machine, and the noise of the machine itself, those huge monstrous shear machines cutting a dozen 1-inch bars at a time, the bars falling into the receiving bins, the noisy crane continuously passing overhead carrying bars to be straightened and taking away bundles of bars that had been straightened. One could not hear his partner talk unless the partner, who was only 6 feet away, spoke at the top of his voice. We were five men on the machine. Four men worked as one rested. Each man worked two hours and rested a

half-hour. . . When I saw the bathroom, I was horrified. It took me several years to get the courage to use it. They called it by its appropriate name, "The Shit House." I usually jumped the fence and went behind the bushes.

The Inland Steel bosses were great practitioners of nepotism. They did not believe in seniority. A brother, a son, an uncle, a cousin, or a very good friend had high priority toward a promotion or a better transfer. Those workers who went to the boss's house and dug his garden, painted his house, cleaned out his basement, had his wife help the boss's in doing house cleaning.

It was the year 1933, and Chicago was about to open its doors to the World's Fair. I applied for a job there, and with the help of a local politician, got the affirmative nod. They gave me a letter of introduction. I was to go to the Italian Pavilion one week before the opening date, present the letter to the person in charge, and start working.

The next day, I told my boss that I was quitting within about a month because I got a job at the World's Fair in Chicago. "You need a permanent job," he said, "because I understand you are going to get married. The fair is in Chicago, and that means getting home late at night, and then the work is not permanent; it is only temporary." "Well," said I, "if I accept your offer, is it a sure thing, or is it just a politician's promise?" "It's guaranteed," he said. . . .

Well, the World's Fair opened amidst great fanfare. I did not go because I was more interested in a permanent job, because in a couple of months I was to be married. The day of the third shift arrived. I was to work the night shift. I went there to assume my new duties. To my consternation, I found another man on the job. I became so angry, I flung myself at him and just beat the hell out of him. Never in my life had I seen such a black eye. It had a telescopic protrusion. He became wild. He was mad. He called up the entire office force, from the general manager to the lowliest bookkeeper. He told them that a riot had broken out. They all came down. They called the police and had me arrested. . . . I never thought I would ever resort to something like that, and nobody at the steel mill thought that I would do such a thing, but it happened. The wedding day was approaching; the Montagna family had sent wedding invitations, and there was I, arrested, fined, and unemployed. And the country was in the worst Depression in its history!

I was happy because I had married the prettiest girl in the world. To this day, I believe that she was and is the best bargain of my life. When we came home to Chicago Heights, we came to face reality. We couldn't afford to pay anything, so we lived with my parents for a while.

Albert and his bride Cecilia Montagna went to Niagara Falls on their honeymoon in August 1933.

The La Morticella family is shown here in the 1960s. They are, from left to right: (front) Cecilia, Anthony, Albert; (standing) Flavio, Martha, Camelia, Maria, and Robert.

Roosevelt had just been elected president. Immediately, he instituted. . . the WPA—Works Progress Administration. I was getting $94, because I was teaching Italian and also citizenship to the foreigners. I managed to help hundreds of foreigners to become citizens. That was how I became known to the foreigners. Later on, they called me to help them get relatives admitted from Italy and to make translations for them. Later on, I was called for help in the preparation of their income taxes, etc. Ninety-four dollars a month was hardly enough. However, we moved to an apartment and paid $25 a month.

One year, Christmas was approaching, and we had absolutely nothing. We said, "This year, no fancy dinner for Christmas Eve and Christmas Day. We'll get some cheap toys for Maria, Robert, and Martha. . . we can't

disappoint them. They wouldn't understand if we tried to explain." As we were contemplating the lean Christmas we were to have that year, it was December 23rd that night, and we heard a knock on the door. A young man came in with a 100-pound sack of Cerasota flour. He went out and came back with another big box; he went out again and came back with another box. I said, "I'm sorry, but you must have mistaken us for someone else. We haven't ordered anything. You must have us confused with someone else." He said, "No, and my father wishes you a Merry Christmas." It was the anarchist's son, his father being the man for whom I had done the translation. The boxes had everything needed for a hearty meal for Christmas Eve and Christmas Day—fish, 2 gallons of olive oil, a gallon of wine, assorted fruit, nuts, meat, cheese, cold cuts, and other things.

Albert and Cecilia La Morticella are pictured in the backyard of their home at 240 East 22nd Street in Chicago Heights in the 1950s.

When my father came to Chicago Heights, there were no insurance agents, and when a husband died, it was also a disaster for the bereaved family. They tried to institute "*Societa di mutuo soccorso*" (mutual aid societies). Prior to the coming of these lodges, it was my father and a friend who were the official alms collectors. They brought along a tablet and a pencil, and went from house to house collecting money for the widow and children. The people would write their own names in their own handwriting and the amount they wished to contribute. And so life insurance sold and serviced by honest men has its legitimate place in our society. Some of the old lodges are still in existence. One has 500 members, and when one member dies, each member pays his mortuary dues of $3—a total of $1,500 in all.

I went through many experiences; we did it, but we still can't explain how we did it. We remember when Flavio, as a child, had virus pneumonia, 23 days of fever; we remember when Maria had scarlet fever. That is when it ruined her eyes. We remember when Mamma was pregnant with Martha, and for nine months she had a terrible cough. For six months, she couldn't lie in bed. She slept sitting in an armchair near the pot-bellied stove with blankets around her. We remember when you gave us cause to worry. Let me tell you, Nino, I would have had a nervous breakdown if I had to face all those hardships alone, and I think Mamma might have had the same misfortune if she was alone.

In his later years, La Morticella taught non-credit Italian language classes for Prairie State College where his students were mainly second and third generation Italian Americans.

JOE BRUNO

The Proud Artist's Touch

"Where I came from, we didn't even have water in the house."

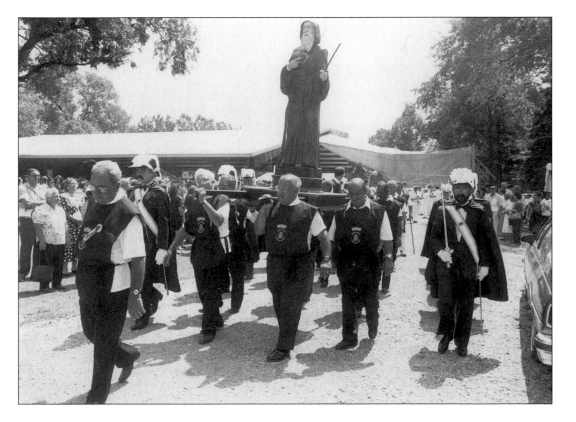

One of Joe Bruno's proudest achievements is the establishment of the Feast of San Francesco di Paola to maintain and expand the Calabrese regional culture. His efforts have brought out large crowds and won plaudits from Calabrian Regional Government officials and journalists. (UIC IA 55.35.)

Joe Bruno is an independent, proud, and generous man. A teenage immigrant from Calabria, he came to Chicago in the early 1960s, with only his skills as a furniture maker. A lifetime of hard work made his "artist's touch" something sought after by the city's top interior designers and their celebrity clients. This interview, done in the mid-1990s, well documents Bruno's values, and it well illustrates why Calabrian Italian officials and media have toasted him as a model Italian immigrant.

JOE BRUNO JANUARY 5, 1994

I was born in Morano Marchisoto, a town of around 2,000 people. I come from a family of cabinetmakers. My father was a cabinetmaker, and I was helping him when I

Preteen Joe Bruno poses with wood outside the family cabinet shop in Marano Marchisato in 1953.

was very young. In the village you know, you have got no choice—your father is a cabinetmaker, you got to be a cabinetmaker. So I moved from my town to the city of Cosenza, which was a little bigger, about 100,000 people, and I started to learn my trade as a cabinetmaker. Then I came to this country in 1960. I was 24 years old, and I started with a company—Parente and Rafaela—to do custom-make furniture. My story is like any immigrant story—you start from scratch.

In the beginning, it is not easy—you don't know the language, you don't know nobody, new country, new life—start from scratch. I was lucky I was a cabinetmaker. I had a skill in my hands, which helped me a lot.

In my village, most of the people were like cabinetmakers, bricklayers, mechanics, shoemakers, and tailors—a lot of tailors. Hart, Shaefner, and Marx here in Chicago had a lot of people from my town—a small town. . . .

My father came about four years before me in 1956, and he helped to make room for me. I was born 1935. I remember the world. . . . the Germans—I remember we were always hungry, nothing on the table, no bread.

For some reason, I never really liked school, believe it or not. I never concentrated; my mind was to do the furniture, because I wanted to be the best. In Italy, where I come from, you have no choice, you got to be somebody if you don't go to school—you got to learn to do something. So when you are 23, 24 years old—you go to the Army for a couple of years, and then you gotta start a business for yourself—a little shop to do the furniture, or tailor to make suits. This is what I did. I loved it because I knew I could do it. You believe in yourself, and that I wanted to keep doing it—I wanted to be the best. When I was 18 years old, I was already a pretty good cabinetmaker.

I was never crazy to emigrate—to leave my friends and my family. . . my mother, my

sister, my brother—but I went to the Army, and that life was tough. After six or seven months, someone told me that if you have someone in the family in a different country, they can call you over. I told my father, "I want to come to America. I want to try. I want to see," and this is what happened.

In 1960, they gave me the OK. There were a lot of people from my hometown in Chicago—because one would call the other one, there was a lot of people I know.

My father had a third-floor apartment near Sacramento and Polk, which was nothing special. But for me at the time it was special because I found a telephone hanging on the wall. In Italy, where I come from, there was just one phone station in the village. For me to see the phone hanging on the wall, I says, "this is the real America!" From where I come from, we didn't even have water in the house. In 1960, the water was outside, and everyday my sister and my mother would go and get the water.

My father gave me one week of vacation, and then he already had a job for me. I worked one week where my father was a cabinetmaker, but it was production, and I didn't like it. I said, "This isn't no job for me. I want to build furniture. I want to make custom furniture," and so the boss said, "I can tell you know your business and this isn't the place for you." He recommended me to his cousin, who was Parenti. At that time, it was a small company—five or six people. So I went and asked for the job, and he said, "Where do you come from?" "I come from southern Italy. I don't speak your language." He said it was a little hard to hire me, so I said, "Listen, hire me one week—you don't have to pay me. You try me; if you think I'm OK, I stay, if you don't think I'm OK, don't worry about it." So he tried me, and after one week, he said, "I think you do OK, and we want you to stay with us." It was six months that I worked with the company, and there was a problem to put the finish on the furniture, to put color in the furniture. Little by little I started being interested in finishing

"Measure twice, cut once." Young Bruno works on a table in his Italian workshop. When he grew up, every boy was expected to learn a trade.

furniture. In Cosenza, I used to finish furniture too. When I started finishing, all the interior decorators liked my style, and I started feeling that people liked the way I do, so I forgot about making furniture because there's a lot of competition, but to finish furniture was very difficult to find somebody good. The interior decorators were interested in my "artist's touch," and I started to love it when people said I was an artist.

I used to be a member of the Italian Catholic Federation—Our Lady of the Angel. Three days before I was ready to come to this country, my future wife—one, two, three, I fall in love with her. I didn't even talk with her. I said, "Hey, this is my woman!" I saw her

at a relative's house. I knew her because she was born in my town, then she moved to Catinjaro(?), 100 kilometers from my town. I knew the family, but really I didn't know anything about her. So, three days before I was supposed to come in America, I fall in love with my wife, and I tell her, "I'm going to America," and I said, "If you trust me, I like you; I don't know if you like me, but I'm going to America. I'll make some money, and I promise you, in three years I'll come back, and I'll marry you." So this is what I did. And I worked hard because I got to go over there, and I got to make a nice wedding. Then I bought a beautiful car—a nice Chevrolet Impala. I brought to New York, I put it on the ship, and I took it with me to Italy. After three years and a few months, I got married, and then I came back by myself. At that time, it was hard to take your wife with you because I wasn't a citizen yet. My wife came in 1966, but I went back one time. So when she came here, two months later she already had the first child.

In 1966–67, we moved to Elmwood Park. I bought an old house, and I fixed and I remodeled and loved. I was still working for Parenti for about 20 years. I was in charge of the finishing department. I worked with interior decorators—famous people. I was running all over the country. About 15 years ago, I was in Aspen, Colorado, to do some work for the chairman of the board of Sears. I did work in England, West Palm Beach, Los Angeles, and a lot of places. I restored a desk for the wife of Cuba dictator Batistta. She lived in West Palm Beach, Florida.

This is the way my mother taught us—we

Giuseppe Bruno's 1963 passport is shown here.

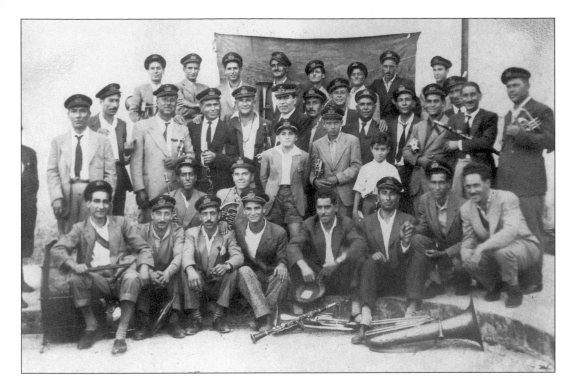

Joe Bruno is shown here in the second row, second from the left with members of the town band, c. *1954.*

cannot miss mass on Sunday. This is my culture. This is my religion. This is the way I am. To me, I respect everybody, but I want people to respect even the way I am. When I moved to Elmwood Park, I started to be close with the Italian Cultural Center. Fr. Feccia, he started to call me—my friend Dario Zamichelli—and we tried to do something to help. And then there was my friend Robert Simonata (?), that's when I started really being involved with the Italian Cultural Center. I started being friends with him, and he gave me the job to be chairman of the dinner dance. I remember one year with Father Roberto; I think I sold maybe 300 tickets.

If you're good, nice, honest with people, you make friends, you can make friends, but you gotta be nice. You got to try to do your best. I got people from all over—from north Italy, from Sicilia, from Calabria, from north Venetia. I don't believe this—if you are from Calabria, your friends have got to be Calabrese. One of my best friends, Dario, is from Reggio Emilio. We are good friends.

In 1982, we started the San Francisco feast. We were talking about doing something for the Calabrese people, and Father Robert gave me the idea to do something with San Francesco di Paola. It was a lot of people, but there was nothing for us. It was a dream to say it was easy, but how can you? So he pushed me to organize a mass; we advertised a little (?) on the radio and called people on the phone, and the church was full. The next year, Father Robert gave me the idea to maybe do it outside in August. Every year we see it grows 20%, 25% more people. Now, even in Calabria we got publicity from LaRai. Last year, we had somebody from Rai TV—he took movies, and he put together a 55-minute film, and he put it on National Italian

TV in Italy. For the last three years, they have sent folklore groups; the region pays for their trips, and rest we take care of. Now the Region really is close with us. I think we got about 4–5,000 people.

I deal with these kind of people (celebrities). For me they are just customers, plus I don't watch a lot of television—especially sports. This interior decorator called me and said, "Joe, you gotta come with me. I'll take you to Mike Jordan's house." And I said, no joke, for me it was just a name. I said, "I don't go to anybody's house. I'm a busy person. People know me, they send me the job, I do the job, I send the bill; that's the way I work." I said, "Who's Michael Jordan?" She said, "Come on! Don't make me laugh! You mean you don't know him?" I said, "No." She said, "This is a big

Bruno, far right, is pictured here with army buddies in Rome, 1959.

star." When she said that, I thought he was a movie star. "No, no, no," she said, "he's a player." What kind of player, "Soccer?" "No, he's a basketball player." I said, "It still doesn't do nothing for me, because I don't even know him. You think he knows me? If he don't know me, how can I know him?" Then my nephew heard this, and he told me, "Oh my gosh, you gotta go to this house. I will come with you." And I said, "But who is this guy?" And he says, "He's the best basketball player in the world," and I said, "Still he no do nothing for me." Anyway, she convinced me and everyone convinced me to go see this Michael Jordan. At that time, he lived in Highland Park—a brand new house. He was living with his brother and his mother. She was the boss of the house; you could tell it. She started talking with me. "I want this! I want this! I want this!" And I told her, "Listen, I'm working with the interior decorator, and what she tells me to do, I do. I'm supposed to copy a table from New York, and I had no problem to do the same finish as was on the table. The only thing is—I want the table in my shop to copy." I wanted someone to deliver it to my place, to match the table, and then send my work and the table back to her house. But she said, "No, no, no, this table's got to stay here. I want you to make a sample, and then it would be your problem to match." To me, it would be very difficult to do. The (decorator) she convinced me, "Please, please, this is a big customer. I don't want to lose this job; please do it for me." So she convinced me, and I did it. Three days later, I went back by myself, and I showed it to Mike Jordan's mother, and I said, "What do you think?" She said, "The decorator is in charge." We showed it to the decorator. The decorator said, "I think it looks good." She (Mrs. Jordan) said, "I don't think so." So they convinced me again to make another sample. So I made another sample, go back and show my second sample—it was beautiful. I was proud, and she started to say, "It's a little too dark." I told her that I still think I need the table in my

Joe Bruno was out not only to see the U.S. in his Chevrolet, he brought the gargantuan Impala back to Italy with him for a visit.

Joe promised Mimma that he would come back for her and marry her. . . and he did.

Bruno poses with a futuristic table he created for Michael Jordan.

place to match it perfectly. And she said to me, "Mr. Bruno, if you want our business, you've got to make another sample." I said, "First of all, I didn't call you, you called me. If you think I need your business, you're wrong, because I don't need your business. I'm going. Goodbye!"

I did a bedroom for Oprah Winfrey. She came into my shop a couple of times. We make jokes. I said, "You take care of your show, I take care of my furniture."

I believe in life if you like what you do, you can make a good living, plus you can be yourself.

EDWARD BALDACCI

A Lifetime of Music

"When I was 10 or 11, I played at the Chicago Theater for a week."

The SFBI Second Annual Bachelor's Banquet was held March 6, 1938. The evening's entertainment included funny hats, boutonnieres, and music by an accordion/saxophone duo. (UIC IA 55.35.)

Ed Baldacci was a second generation Italian American who grew up in the 24th and Oakley neighborhood; then he lived most of his life in Roseland. His talent as a musician, his experience in World War II, and details of his home life are well documented. Anthony Mansueto conducted this interview in 1980, as part of the Italians in Chicago Project. The project recorded and transcribed more than 100 such interviews, and they are available to researchers in several repositories, including the Italian Cultural Center in Stone Park, Illinois.

BALDACCI

I was born on June 29, 1925, on 24th and Western. We were nine children. In fact, my mother still lives there, and my sisters still live there, on the same block. I went to Pickard School on 22nd and Oakley, then to Harrison High School. We played marbles on the street there, and then we played baseball in the street there and football in the wintertime—touch football. Of course, I was busy studying the accordion, and I couldn't play too much.

I started to study music at the young age of five. My dad was very strict in trying to keep me from getting hurt. Around there we were all Italians. About 26th Street to 22nd Street, it was solid Italians. The only thing that was important to me, I guess, was my music. When I was about 15 years old, I organized an accordion band with a group of guys practicing in the basement. We used to play for St. Michael's carnival, and once in awhile, I used to give recitals. But we had about 15 accordion players, and I used to use Bruno Michelati, who played the clarinet and the sax, and Eddie Bartelini used to play the clarinet. Bruno Pucci was a drummer. But we'd play things like the drinking song from "Traviata," which is easy to play, and the quartet for "Rigoletto," which was Italian, and naturally the people loved it. There was a lot of Italian songs that we all knew—

"La Spagnola" and "Non Ti Scordarti Me" and many others.

The first number in *Fiddler On The Roof* starts with "Tradition." I think we had it too—I mean my Italian heritage. My father was a common man. He came here as a young man, and he couldn't speak the language. He sent for my mother; they got married here in 1915. They had nine children. It was rough, but we always had something to eat, and we were clean.

My father came from Tuscany, Pistoia, as far as I remember. Now we went to Italy two years ago. We went to visit there. It's near Via Reggio. My father didn't have a car, so we usually stayed home. He belonged to an Italian club on 24th Street. The big deal was the picnic in July or August. We would all go to the picnic, and my mother naturally would bring the mostiaciolli, the raviolis, and all. She would even feed the baseball team. I used to play [the accordion] because my dad used to bring me all over on the streetcar, or somebody had a car and used to bring me to play at these different places, these Italian clubs—the Verdi Club up north, the Mazzini Club. I even came out here in Blue Island one time to play at an Italian club and the Operetta Club in the Roseland area. I used to play practically every Saturday night. My dad used to bring me there. I helped the family make a couple of bucks. In fact, I played in the tavern there on 24th and Western—I was nine years old when I started to play there.

I played until I got drafted into the army at 18. In fact, they had the bocce courts there. The fellas used to go out outside in the summertime and play bocce there. They served free spaghetti on Saturday night.

Well, one year anyway, when I was I think 10 or 11, I played at the Chicago Theater for a week. We were about 27 kids. It was during the time of Christmas, and I represented Russia. I played "Dark Eyes" on the accordion, and there was dancing.

My sisters would make the Jell-O. My mother, she is still [very] Italian. In fact, she's been here since 1915. So that's what—65

years? She doesn't speak any English at all because she was busy raising nine kids, and being in an Italian neighborhood. . . .

We had an awful lot of beans, but that's what we were raised on. Actually, polenta—in fact, I still love it to this day. . . I would rather have polenta sometimes than a filet. Naturally, we had the old *radicci,* as we call dandelions, in a salad like with the eggs, with the hard-boiled eggs. In the morning, we'd have maybe a piece of bread with a little butter and the coffee, and that's it.

But my mother would make pasta. We'd have it maybe three or four times a week. That was a must. And we would always have soup, every night. I don't care if it was 150 degrees out; we'd have hot soup.

We always had the fagioli, but the main things were spaghetti, mostaciolli, or rigatoni. Once in awhile, she'd make raviolis. For the big holidays, like Easter, Thanksgiving, and Christmas, she'd make the raviolis. My oldest sister, Gina, made ravioli. She brought about 300 or so of them here, and she cooked them here.

There were three places to go. There was the West Side Hall, the Piemontese Club (like for a banquet and things like that), and St. Michael always had something going on in the basement. We'd do some playing there. At that time there was no school, but there is a school there now. When Father Louis (Donanzan) came, he took over, and he built the school and everything. Close to 1950, he built a school, Father Louis Donanzan. He's the one that had the pizza carnival there. He started it back in the 1950s and '60s. On opening night he'd have some great star, an Italian star. I played for Tony Bennett one opening night, 'cause they didn't have a piano out there, so Father called me. We want him to just sing a song as an opening thing, to open the start the carnival, which ran for about 10 nights anyway. Then I used to bring my accordion band out there, too. We played two nights a week or something, for the church.

In fact, I'll never forget when I came back

from the Army. I came back on a Tuesday. Wednesday morning, my dad brought me to the plant. He said, "Well now, if you want a job," he said, "I can get you one here." He showed me where he worked. I said, "No, no, forget it. I'm going to school. I can get three years under the G.I. Bill of Rights."

There was the Modesto Club, then there was the Lovagnini Club. My dad was a member of the Modesto Club. He always was. In fact, the last 18 years when he retired, every day he'd go and play his little card

Eddie Baldacci is shown at age nine in 1934. From an early age, Eddie Baldacci worked as an entertainer. As a boy, his Saturday night accordion gigs got him home so late at night that he rarely attended church on Sunday and had to delay his first communion and confirmation until he got married.

The SFBI, Societa Filarmonica Bella Italia, *was an institution in Roseland beginning in 1911. Eddie Baldacci speaks with great nostalgia of the stimulating music scene in the '40s and '50s. (UIC IA 55.68.1.)*

game in the afternoon. That's the way he would pass the time.

Mr. Maggiotta was an Italian radio announcer. He was associated with Mrs. Santacaterina. She owns Belgo Products now. They make the tortellinis and all that from the North Side. She was a radio announcer, too. Mr. Maggiotta used to run these Italian dramas at the People's Auditorium on Chicago Avenue near Western. I used to be booked, like to play between the acts. I was dressed in an Italian costume or something; I used to play these Italian songs. In Roseland, here, they would run actual operettas.

My upbringing was through a man called Nello Giovanini, who was a guitar player. He never studied, but he learned by himself; he loved opera. I remember going to my first opera when I was about six or seven years old. It was "Catoria" and "Pagliacci" together at the old Auditorium, which is still used today here in Chicago.

In fact, this Nello Giovanini, this guitar player, had a restaurant near 24th and Oakley. All these musicians, even some of the musicians from Chicago Symphony, would come there to eat 'cause he was such a great cook.

Then he got into partnership with a woman who was across the street on Oakley, on the west side. That was called Lucca Restaurant because these people came from Lucca. They naturally loved the Puccini operas, like "La Boheme." Of course, all the Verdi operas too—"La Traviata," "Rigoletto," and "Trovatore."

The restaurants, I can rattle 'em off, but you probably know 'em anyway. Febo, Toscano, Bella Bruna. There was Gino. Gino was just like a bar thing there. There was a Club House Café, and during the war or after the war, Marconi came and La Fontanella.

The clothing place had a Jewish owner; he would have the clothes outside like Maxwell Street. I remember my mother—him

Eddie Baldacci wasn't the only Italian American accordionist in Chicago. Al Carsello had this promotional card made that touted him as "The Accordion Master."

speaking in English, and my mother speaking in Italian, yet they understood each other. I don't know how they did it. My mother would say, "Too much," or "*troppo, troppo.*"

Borsini was a grocery store right on the corner of 24th and Western, there was the Fontana Bakery on Oakley Avenue. Then there was Perri. Now that was another clothing place. Maybe he was more expensive than the other guy on 22nd Street, I don't know. There was Bruno, and the Petri's barber shop on Oakley. At that time it was his father, his brother, and him.

There was Fantozzi Insurance, I think it is. He was selling insurance. There was a write-up on him in the *Fra Noi.* a couple of months ago or a year ago. Then there was Bella Bruna. Mr. Fantozzi would get involved in everything around the neighborhood. I think he still does. He was good for the Italians, because he tried to help 'em. Being that he could speak the language. If they needed some legal advice, they would go to him. Not being very fluent with the English language, they had to go someplace.

St. Michael was always in the red until Father Louis came along. Father Louis Donanzan—he was a good priest in the sense that he could get people to start working for him, whether they were Socialists or not. He built that school.

My father never went to church. I'll tell you that right now. We all went to church. I went to church as much as I could, because at night, I could play at the tavern and come home at two or three in the morning. My mother figured, "Well, if you don't go to church, God knows, he can see. And if you don't make your Communion and Confirmation, when you get married, you make it." And I did it that way. I was the only one out of the family of nine kids that didn't make my Communion and Confirmation until I got married. That was at the time that I met Father Louis. I used to go to class, private, in the morning during the week at the rectory.

Whenever he wanted something, like playing or something, I was always ready, because I loved the man. He was a great man. I realized what he was doing for the neighborhood. He put up the school for the kids. I mean, he did good things. He wasn't trying to hurt anybody. So that's the way I felt about Father Louis.

In the early days, sometimes people would try and harass the people going to church. They might harass them if they were maybe talking around the corner. "Are you gonna go to *church?*" Maybe something like that. "You stupid individual." Oh yes, I can visualize that. . . because Nello, this guitar player that was like my second father, he was dead set against the church.

All of the kids of my generation—my brother and my older brother—when it was time for us to go to war, we all went to war. We all were drafted. Some volunteered. Most of us were drafted, and we went. We didn't go against it. We didn't like to go, but we all went. We did our duty the best we could. We came home, and that was it. They even had a victory display on the corner of 24th, right across from our mother's, with the names of all the people who had gotten killed and the people that were in the service.

There was Mr. Silvestri—he was very active in the Italian thing. He did a lot of printing for the Italian banquets; they used to make these books for these different clubs, different organizations. That's how I got my article in that Italian paper, through him. He called his friend, who was a writer for this Italian paper, and he says, "Come to the concert and write something about this boy."

I remember Pearl Harbor. We all got into the assembly hall to hear the president declare war on Japan, Italy, and Germany, right? I remember my division teacher as clear as if it happened just yesterday. He says, "Don't laugh, fellas. Some of you boys, in fact all you boys, are gonna be in this war, and some of you boys are not gonna come back." And then he says, "and I want it understood. . . I know that we have a lot of Italian boys

here. We have a lot of German boys. I don't want no trouble starting because we're [all] American citizens, and we should, we should stick together now."

So I was 16. I figured. . . well, by the time we get to be 18, the war will be over in two years, never knowing it would last four years, five years.

I think the people just did what they used to do. The old-timers anyway. I can say that the effect of the war maybe kept the Club Lovagnini from blasting away a little bit louder than what they might have liked to have blast. The May 1st parades were all of a sudden dispersed.

I came back, and I saw all my old buddies. They were all still living between 22nd and 26th. I think what changed after was when we got married. Some married girls from the neighborhood, but most of them married girls of different neighborhoods, like I did. I moved to Roseland because that's where my wife comes from.

After the war, I went to the American Conservatory of Music downtown. Thirty years ago, I got my degree. I studied with Leo Sardi.

We just freelanced whenever we got a call for a wedding, or a bowling banquet, or an anniversary, things like that. We're only three men—a small combo. That's the way I made my living.

I met my wife, Florence, when she was visiting Maggiotta. It just happens that this Maggiotta I used to play for—he used to give the dramas, and my (future) wife's mother was his secretary. Coincidence, isn't it? I never met her when I was a kid, but I mean she (her mother) used to type all the secretarial work for Mr. Maggiotta. She used to come all the way from Roseland, taking the 79th and Western to Madison; that's where his office was and where the radio station was, Madison and Western. She went

Young men clad in white gather around an accordionist in front of Parise Ice Cream Parlor near 115th Street in Roseland in 1927. (UIC IA 55.55.3.)

Maestro Baldacci in the 1950s conducted accordion classes and formed a youth accordion band.

there to visit Maggiotta. He had a summer home out there in Lake Zurich. My wife is a pianist. He says, "I want you to meet a. good accordion player, and you play the piano, so you should make a *miscia* (match).

When I found out she played, we used to meet once a month with her friends and my friends. I had a friend, Gino Rafaelli, who plays violin. In fact, he plays with the Cleveland Symphony now. We were buddies. My wife knew a couple of singers that she used to play for in Roseland. Once a month, we used to have a musical night. I used to play the accordion, Gino played the violin, my wife played the piano, and Diane Pisetto and Shirley Fisher used to sing.

I used to travel to give lessons. Then I used to have one day in my own neighborhood. I finally worked about four days in Roseland, where I didn't have to travel too much. I still went house to house, but they were all close by.

Roseland? Beautiful! It was an area where we had everything. We even had the Italian clubs and the banquets. Transportation was easy to get at. We had the Illinois Central. We had the bus service. We had the streetcar in those days. We had everything. All the Italians were there. I really was surprised when it got overtaken that fast. I was amazed. Everybody just left so fast. I never thought it was gonna happen that way. I would have been very happy to die there.

We lived on 122nd and LaSalle. We bought

SIAM, The Society of Italian American Musicians, was composed of people like Eddie Baldacci who lived and worked for their music. From Cesar Petrillo on down, Italian Americans played an important role in the world of music in Chicago.

a nice home back in '58. The kids went to Gompers School. Then they went to Fenger. It was just beautiful. My son was in the Little League. We were very happy. Believe me, I became a basket case when they (minorities) moved there almost.

I was a player who could play Italian music, let's put it that way—never advertised my playing and so forth. It was through (word of) mouth and giving lessons that people found out I was a teacher who gave lessons.

The Operetta Club would have a gathering. They'd all get up there like a choir. Then they'd have the soloist sing. At that time Frank Bortolai was the big boy in

Gazing at this photo, you can almost hear the Christmas music Eddie played when this photo was taken in 1978.

Roseland. He was another great man who played the accordion quite well. He could play all the Italian songs. He loved to play. Frank, he's dead now, but he really was great. He had a studio on 115th , east of Michigan. He was very active with the Italian population. His father was even greater as an accordion player. We were always good buddies. There were people who were trying to get us to (compete), like one would say. . . "Well, Eddie Baldacci is better." "Oh no, Frank Bortolai. . . . ". . . well, that happens in anything. That used to burn me up because I never tried to outshine nobody. I'm Eddie and you're Frank. You do your best, I do my best. That's it." There's enough for everybody.

St. Anthony. There was a great meeting place. St. Anthony was even better than St. Michael. I have never met any class of people who were so devoted to doing so much for their church like the people in Roseland. Because I think, on 24th Street, you had the socialistic environment there. Understand? That's what made it different. But here (Roseland), they were all for the church. I mean 110%.

My dad gave you the impression that he was the authority, but I think my mother was the one who raised us nine kids, because my father was bringing the money home from where he worked, and he'd give it to my mother, and she would pay the bills. Now see, my mother couldn't speak English, but she knew the $10 bill from the $20 bill. She knew it. She learned. She learned to count. She took care of all the paying of the bills. I do the same thing. My wife manages the money. In 31 years that I've been married, if I wrote five checks. . . . My wife. . . or I'll say . . . give me five bucks or give me ten bucks. I guess, because my father did the same thing.

GLORIA BACCI

A West Side Story

"I can remember during the war years when my boyfriend was away in the Army."

Renato (Ray) Bacci, home on furlough, poses with his parents and his sweetheart near a street corner tribute to the men in the service from their West Side neighborhood.

Mary Piraino conducted the Gloria Bacci interview on April 9, 1980, as part of the Italians in Chicago Project. Her granddaughter, Lisa Bacci, provided editorial help and photos in presenting this interview. Gloria's life is typical of the second-generation woman. Her memories of immigration stories, her childhood on the West Side, wine making, the May Crowning, and her long distance courtship with her GI boyfriend during World War II are classic tales. Her comments on the Italianness of the mid-West Side near Our Lady of Sorrows and Holy Rosary remind us again how neighborhoods have changed in Chicago.

GLORIA BACCI

My mother (Guerrina Bozzi) and father (Archimede Talevi) came here in 1922, of November. When my father came to America, he was a meat packer in Italy, and they called him to come to America to work at an Italian packinghouse here. . . 1300 North Sedgwick Street. It was called the Ideal Packinghouse.

When he came to America, he was 29 years old. Well, early to this my father had come to Seattle, Washington, up in Spokane, Washington. My father came here with his father to work on the railroad. He was then only around 14 years old. In the meanwhile, war broke out in Europe. His mother wrote and told him that he must come back to Italy to serve in the Italian army. So my grandfather and him went back to Italy, where my dad became a soldier for Italy. After the war, he decided to come and live in Chicago. Right after the war, he met my mother.

They were dating for a while. . . European style. Then they decided to get married and come to America. They were from Pesaro, Le Marche, right off of San Marino. It's a beautiful place. Within five years, half of the village came to that one section of Chicago.

My Dad had a job here. They were waiting for him. Yeah. At the time, it was my mother's uncle who brought them to America. And my mother came with him, she was then pregnant, like eight months, they moved in with relatives. This was around Thanksgiving. My mother was so surprised of seeing this large bird, which in Italy there was no such thing as Thanksgiving dinner. But her uncle greeted her with this big dinner, and they were very happy. I was born to my mother a month later, December 26, 1922.

They didn't live with my mother's uncle too long. They then decided to go in a little apartment long after I was. . . oh, maybe walking, or two years old. They moved on Van Buren and California, where we all grew up. We're three sisters, and we grew there on Van Buren and California. I am the oldest. Dorothy is 27 months younger than I, and my sister Norma is 12 years younger than me. Myself and my very young sister, Norma, were baptized at the Assumption Church. My sister Dorothy. . . they baptized her at Our Lady of the Angels. I believe I was around six years old when I started school. I was afraid of the nuns. They put me in the Blessed Sacrament School. But never seeing a nun in my life before, and only speaking the Italian language, I was lost entering first grade at this time. I stayed there for a year, maybe less.

Then we moved, and I was put into Our Lady of Sorrows. It was an Italian neighborhood; Van Buren was quite a bit Italian. Kedzie, Polk, and Harrison. . . they were all, all Italian. I remember our very first apartment where we lived by ourselves was at 2810 Van Buren. And it was. . . oh, what would I say. . . two bedrooms, a kitchen, front room. I can remember an oil stove where we would have to go up and down to the cellar and bring up oil. Then in the kitchen, we had a small garbage burner, which we had to put coal in and had to keep feeding coal to keep us warm during the night. Winters in Chicago are cold, and in a stove-heat flat, twice as cold. . . .

Guerrina Bozzi's 1922 passport indicates her birthdate, that she is married, that she knew how to read and write, and that the police have given her permission to emigrate. Documents like this are to be treasured both as mementos and for the information they contain.

[But in summer], I can remember my mother would look in the ice box early in the morning, and she would say "Well, we're almost out of ice." They had a very large sign that read 15 pounds, 25 pounds, and 50 pounds. And my mother would put the sign in the corner of the window as the ice man came by, he would see it. . . and the next thing, he'd be coming up the steps with it. . . it would cost us maybe 25¢ or 35¢ for the lump of ice. It would last a day or so. It depends, you know, the hot weather. And I can recall my mother, too, making fresh lemonade with fresh oranges and lemon. And she would chip a couple pieces of ice so we would have cold lemonade.

I can remember our holidays. . . my mother making raviolis and tortellini, and of course, our roast beef and sausage. Well, in those days, the girls were real old-fashioned to make homemade pasta. My mother demanded that I learn. She kept saying, you must learn, you must learn. So she would start the flour and the egg batter, and then she would start rolling it where I would have to take over to roll it thin so we could cut it and make raviolis. We still do make homemade ravioli for the big holidays. . . Easter, Christmas, yeah. She'd have a plain beef, veal, and pork meat, and then our spaghetti, our tomatoes, garlic, and onion. That would have been the beginning of our spaghetti sauce. Early in those days, all the girls from Europe used to make homemade tomato paste.

To pass the time, I can remember real well, we used to go down in front of the little store I was working, we'd put some money together, and we would get a bicycle. It would be like three hours for a dollar. And we'd use the bicycle for the evening.

My husband, Renato, to begin with, we had gone to the same school, Our Lady of Sorrows. We were friends like that, but as we grew up, my mother used to tell me that he was a nice boy. He spoke Italian, and I would have a nice life with him. . . . But turning 18, he asked me to go out, I was all excited, and this is how we started. . . . But then my husband, more or less, we got serious. When the war broke out, he says to me if I would take his engagement ring and wait for him. My mother liking him so much, it made me very pleased. So I accepted the engagement ring and waited for him to come home from the Army.

He left in '42, I would believe. We would write just about every other day. . . we'd send a letter. We would just write. As often as I got a letter from him, I would send one back, because at that time there were what they call v-mail. . . But there were times that he would tell us where he was in Europe, and the government would snap it out of the paper or mark it out. So we wouldn't know where he was or anything. . . . So I says, "Can you more or less tell me where you are in different ways?" He later on sent me a picture of him in a pair of kilts. And he says. . . "Would this give you an idea of where I'm at?" "My outfit will tell you where I am." We knew then that he was somewhere in Scotland or Belgium, where the war was real bad at the time.

When we married, it was a Sunday afternoon. It was around a 3:00 wedding; it was without a mass, because in those days, it was just more or less the marriage vow ceremony. It was a very hot day that we can recall. . . in June. After we had the wedding ceremony at the church, then we came home to my house for an hour or so, and then we all went to the hall. . . . In those days, we did not have a sit-down wedding. It was just beer and roast beef sandwiches, and all the homemade cookies mother could make and people that helped her. . . . It was on 5th and Madison, and all age ranges, from the elderly to the little, tiny babies.

We moved to Kedzie and Chicago—oh, it was beautiful. You'd walk from one end to the other, Chicago Avenue, past Cicero. . . all Italian. We had our supermarket, butcher, dry goods store, dime store. You could walk there and talk to anyone, and you would speak the Italian language. We knew

Little Gloria Talevi, 2 1/2 years old, plays with her doll on a street corner on the mid-West Side in the mid-1920s.

The Talevi family of 320 South California is depicted as described by Gloria in her interview, c. 1941. They are: Archimede, 49; Guerrina, 39; Gloria, 18; Dorothy, 16; and Norma, 6.

everybody in the neighborhood. . . all the shopkeepers, yeah. When I had my children, I was still working in this little Italian grocery store. . . . I had a dear mother-in-law that, she moved in with us, and I had her from the day we got married until now. . . . So I more or less would leave, and I never thought of the children because I had such a good mother-in-law there to watch 'em. On account of her, my three children (Renato Jr., Tom, and Mary Lou) all have their second language. They read and write Italian.

My husband's family is Tuscan; they're from Lucca. Their province is Fornaci di Barga. Grandpa and Grandma Bacci, my

mother-in-law, is a Marchetti, which is a very popular name in her part of town. She was the oldest, again, of nine children in her family, and they lived on a big, big farm. Her husband was one of 12 kids. He was the baby of the family. He never remembered his mother and father, because they died at his birth. He grew up with sister-in-laws. . . his sister-in-laws were as old as his mother and father, some of them. Yeah, his name was Peter Bacci. My mother-in-law is Maria Bacci. My father-in-law came here in 1909, leaving my mother-in-law behind as his girlfriend, promised her that as soon as he had a little money, he would call for her. From 1909, it went to 1913. . . where he brought her over in May.

My father was the oldest of nine children; they lived on a very large farm. The way I can understand, for the first years of my father's life, they were renting the farm, and they would have to split the crops, half to the owner, and the other half they kept. But as the family got older and there was a little more money, my grandfather bought the farm. From that time on, it was theirs. My mother, she was the only child in her family. She's from a little town—they call it San Giorgio. And her daddy was the mayor of the village. He was the only man that knew how to read and write. He was mayor until my mother was well grown, where she was put in a school run by nuns where she learned how to do cut work and fancywork. She was educated there. . . because they were a little bit better than some of the other families. Not to be a nun. More or less to be educated. . . when she was in the convent, she would be there for weeks, then her daddy would go up there and get her on weekends and bring her home with a horse and wagon. …

But my mother's life was nothing like my father. My father had a very hard childhood, because they were a very large family. I can remember my mother telling me that when she would go to school, she would offer the children her white bread made with white flour. . . to the children who had nothing but

cornmeal.

Making wine goes back many, many years. When we were little girls, my father always made wine. It would be once a year, and it would be sometime in October. My father would have saved money, and we'd go to Chicago near Cicero. There's a railroad track there where he would buy maybe a hundred, two hundred cases of grapes. He would buy so many white and so many muscatel, and the others were Zinfandel. He would put them together and try to make sort of a sweet wine. . . We were allowed to make 200 gallons of wine. We'd have to have a permit. The man at the tracks would give you a permit, we would send it to Washington, D.C., and they would OK you to make 200 gallons of wine. Making wine was more or less their. . . the biggest thing in their life in Europe was raising the grapes all summer long, and then comes October, they would make the wine. He made it more or less the same. We would have barrels all along the basement wall, my father would go from one barrel to the other. He would put one or two cases of grapes and grind 'em up. After maybe five days that the grapes were being fermented, he would put 'em in a winepress and start pressing the grapes where the liquid of the grapes becomes wine. When he first came to America, like my mother would have loved to have a front room set, my father wanted the wine press, the wine chopper, and barrels so he could have made wine that. . . first year , from the first year they were here.

I can remember during the war years while my boyfriend then was away in the Army. I joined the Young Ladies Sodality at Mother Cabrini Church. Around the middle of May, the church would have what they call a "May Crowning," and they would select one of the girls to be queen to crown Our Lady. All the other girls would be dressed in long pastel dresses. We all carried sort of a gladiola in our hand. We had the procession of crowning Our Lady on a Sunday afternoon. All the mothers and dads would see this. . .

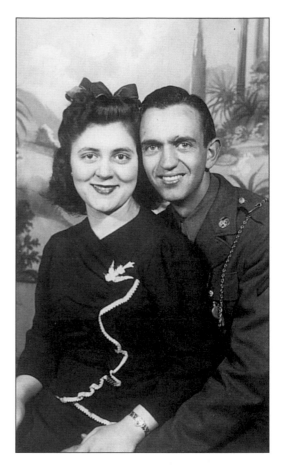

This is an engagement photo of Gloria Talevi and Ray Bacci, c. 1942.

which was really beautiful. . . . Then after that, in order to finish the evening out right, we'd all get on the El and we'd go to the Aragon Ballroom for many hours to dance out there.

I think (my daughter) Mary Lou is the only one that will carry. . . . I think she will try to keep some of the Italian traditions. And I think (my granddaughter) Lisa would like the Epiphany. This is something she really enjoys. Right now we have four generations in the family.

Archimede Talevi grinds the grapes before they are pressed in the wine making process, c. 1964. Almost every Italian American growing up in that era has vivid and detailed memories of wine making in their family.

JOSEPH FARRUGGIA

La Festa e La Musica

"Aha! He's Aragonese!"

The Aragona Club, 1964, at 28th and Lowe was a mutual benefit society and a neighborhood club that sponsored social and musical events. Joseph Farruggia, our narrator, stands in front of the steps.

This memoir by Professor Joseph A. Farruggia came to me through the Internet when I let it be known that I was doing an oral history of Chicago Italians. Farruggia is Professor Emeritus of Music at Humboldt State University in California, and his vivid memories of the Aragona Club and its band recreate the ambiance of the old neighborhood in the Bridgeport area. His retelling of his experience with folk medicine will bring back warm memories to those who grew up in the '30s and '40s. Professor Farruggia also supplied several of the photos in this segment.

THE ARAGONA CLUB

I grew up in Bridgeport. "Hizzoner" lived only a few blocks from me on the South Side—28th Street and Lowe Avenue. The SS Aragona was there, made up of men from Aragona (AG). The club was an unbelievable place, except if you were Italian (Siciliano).

The Aragona Club was founded on February 1, 1932, at 2819 South Lowe Avenue, in the community of Bridgeport, 11th Ward, Chicago, Illinois. Men who lived in Aragona, Sicilia (Provincia di Agrigento), created the club. These men immigrated to America during the early 1900s and early '20s. They were uneducated; none went to school. Many of them had worked in the sulfur mines as young as age 14. Several of the men had stooped shoulders from carrying bags of sulfur. When "outsiders" saw this, they said, "Aha! He's Aragonese!" While the mines no longer exist, Aragona is still known for its sulfur. Others worked in the agricultural fields. On the Sicilian map, one will find Aragona about 15 miles west of Agrigento.

In the photo on pages 90 and 91, difficult to read, but above the apex of the building, this sign reads: "SS. Aragona" signatured in city hall as *Societa' di Mutua Soccorso*, Aragona, Sicilia. Not to get confused, the steeples above the club are of St. Anthony Church.

In the photo, notice the ground-level windows. This was the "basement," where the men gathered after work and played cards, including: *Scupa, Briscola*, and on occasion, *Zicanetta* (a gambling game). Most men smoked the black, twisted Italian cigars— brand names De Nobile and Parodi. I like to boast that my father cured me of any notions of smoking at age 16, by having me puff on a Parodi. Dizziness, nausea, and coughing—that took care of any smoking career.

The men also made their own wine—a dry, red wine. White grapes were shipped by rail from Fresno, California, while the red grapes came from Michigan. We were informed when the grapes hit the train station, and anyone with a truck drove madly to load up the boxes.

We were fortunate in that all the men helped unload and packed the boxes together. When the call came out to crush the grape in a manual crusher, a circular gatelike structure, more than enough men showed up. First, they poured the boxes of grapes into the crusher. Then, typically, two men would begin turning the heavy, metal rods in a circular fashion. The grape juice would come out of a spout at the bottom of the crusher. Other workers would then collect the tub of wine, and with a large funnel, pour the juice into 50-gallon barrels. The barrels were "cleansed" previously by burning sulfur sticks into the empty barrels, tapped with a large cork. A wise move, because of mold and/or bacteria in the empty barrels used the year before. All of this happened in September/October. In the spring, the barrels were tapped for readiness. A sip here, and a sip there. A glass here, and a glass there. The cry went out: "*E' pronto!*" It was a mad dash to the bar where one glass cost 10¢! "*Cent anni!*" "*Buona Salute!*" Every year at La Festa di San Giuseppe around March 19, The Aragona Band would march in front of the San Giuseppe statue, held aloft by six (eight?) hefty guys. The band had a total of some 40 members who wore blue uniforms and caps. To the best of my knowledge, there were no, or only a few, rehearsals for the parade. They

brought tunes from the Old Country with them. Essentially, the band members, whose average age was probably 40–50 years old, would dust off their instruments, grab their music, and show up. The starting point was at All Saints Church, the "Italian church" that appears on the cover of *Italians in Chicago* published by Arcadia.

The director would call the tunes. Among them were the "Marcia Reale," written to honor the House of Victor Emanuelle. The band marched through the neighborhoods soliciting funds. After each offering, pinned on the San Giuseppe statue by a royally dressed eight-year-old girl, the band would play the "Marcia Reale." If the offers were meager, the band would play one phrase and march off. If the offers were generous, the entire piece would be played, with the donor proudly listening with those assembled.

To the surprise of today's readers, the band also played Fascist tunes like *"A l'Abessinia; Giovanezza,"* and others. It should be noted that this was in the mid-1930s, before the war. We were in a Depression at that time. Italy and Germany prospered under Mussolini and Hitler. Visitors from those countries would come here to flaunt their prosperity—fine suits, plenty of cash, and of course, *"ll Duce"* was a mutual hero. The Italian visitors took us to *ristorante* to eat. This was an unknown event by neighborhood standards. As a teenager, I played piccolo in the band. I recall the "Marcia Reale" well. As a boy, I listened to the band play *"Fasceta Nera."* This was in the 1930s. I'm looking for a copy of both tunes, which I want to put in my family history book I'm assembling. Words too, if possible. All of this is too precious to not leave with my children.

During the off-season, the band would become the Concert Band. On certain occasions, it would give concerts on an open-air concert stage, adjacent to the club as seen in the photo. The audience sat in folding chairs.

The bewildering fact is that these once-a-year performers played Rossini overtures,

According to Joseph Farruggia, who is a retired music instructor, the Aragona musicians would simply dust off their instruments, gather, and perform great music, with little or no rehearsal.

Verdi arias with invited sopranos and tenors. There were all fine musicians, despite their lack of opportunity to rehearse! They included operettas and concert pieces—Rossini, Verdi. During the off-season, the club members played bocce in the yard.

It virtually brings tears to my eyes when I think that all of this was possible because of a strong cultural heritage. The listeners knew the tunes; the little children were compelled to hear the concerts, and in time would recall the most memorable tunes. My friend Joe Spicola and I were singing (without words) arias from *Trovatore* when we were just kids.

The festa culminated at night with a carnival and stands of all types selling wonderful Sicilian food! *Salsiccia*, cannoli, olives, fried green peppers. . . foods of all

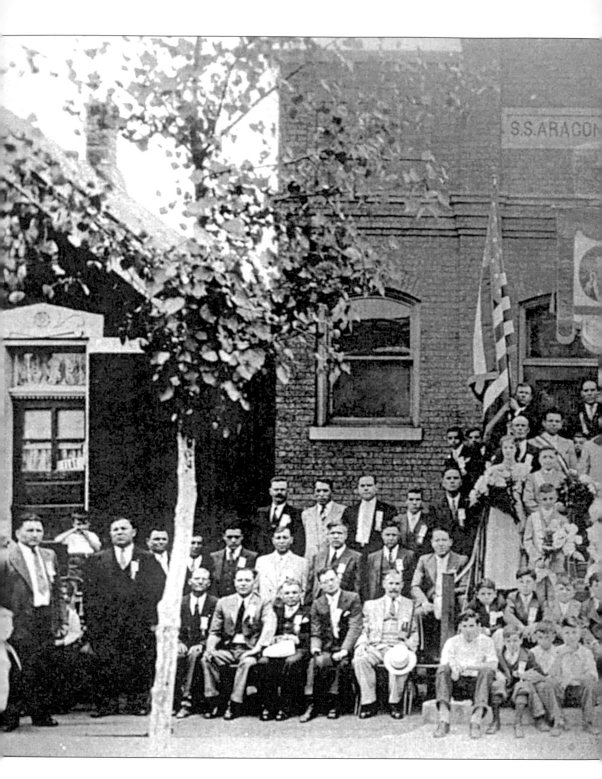

The men of the SS Aragona F. (Fellowship) Music Club assemble with their children on a festive day in the 1930s. The badges, patches, banner, and flags, in addition to the music of

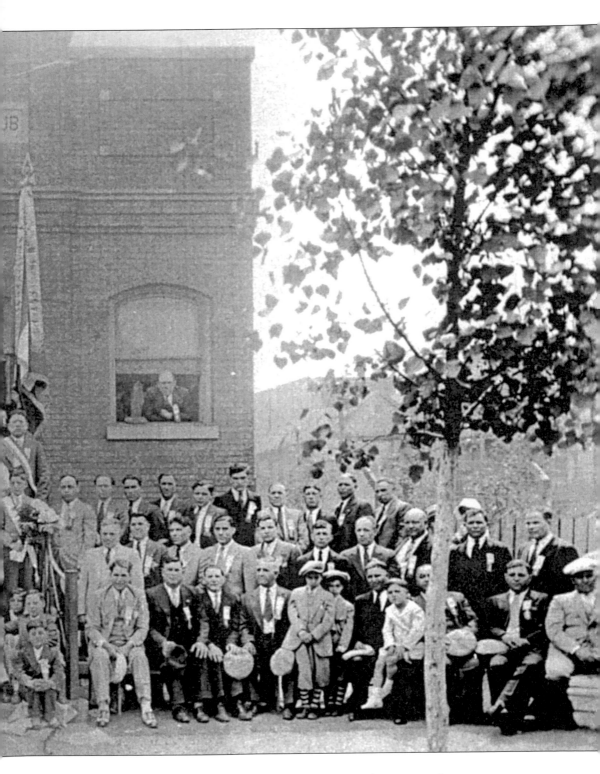

the club, reinforced the sense of community among the Sicilians in Bridgeport.

sorts. This example and others can only stay alive if we give our children alternatives to pop culture. The earlier, the better! As it's often said in Jewish culture, "Pass it on!"

The club members practiced Old Country medicine. In the spring, out came the *sanguetti*, blood suckers. These were available in pharmacies. The idea was to "cleanse the blood" to prevent sickness. The accompanying photo shows that the practice prevails to this day! The *Strega*, a club member's wife, was an integral part of medication. She was called in during stubborn cases. It was believed that she had special curative powers. Her ritual included candles, an icon to Mary, and special prayers.

I'm compelled to tell the following story. I was about 17 years old at the time, living in the frigid weather of January in Chicago. I had a horrible neckache for two days. I consulted a friend and his mother. She said, "*Chiama San Giuseppa, la Strega!*" Donna Giuseppa showed up with her artifacts. She asked me to lie down on the floor, on my stomach. Her equipment included a large, broomstick-like piece of wood. With my hands on the floor, she lit two votive candles, placed opposite my head.

She recited some prayers that I couldn't understand. In stocking feet, she stepped on both ends of the stick. There was no pain during the procedure. Neck pain was gone! One can make what he wants of this incident. I happen to believe to this day in Donna Giuseppa's powers.

Today, the Aragona Club no longer exists. We are left with beautiful memories, and if we are fortunate, photos. The club has been turned into apartments. The stage building is still there but used only for storage.

The Aragona Club was disbanded in 1965, when a large number of members died, and over time others were unable to carry on.

O, cultura Siciliana! Come mi manca sua bellezza!

This third annual picnic of the Aragona Fellowship Club on July 9, 1932, seems to have attracted more women and girls than their St. Joseph festival. (UIC IA 111.24.)

EGIDIO CLEMENTE

Harassed by Fascists, Recruited by the OSS

"I came here in Chicago because the Italian Socialist Federation needed a typesetter."

Future Chicago Mayor Harold Washington was the guest speaker at a Socialist gathering at the Midland Hotel in 1980, which recognized Clemente's lifetime achievements with a plaque. Despite his thick accent, Clemente's speech that night was a barnburner that delighted the audience and earned him a giant bear hug from Harold Washington.

You could make an epic war movie out of the life of Egidio Clemente. Born in the Italian part of Yugoslavia, he survived capricious events of World War I, immigrated to America to join the Italian Socialists Federation in the class struggle, and ended up in the OSS fighting Fascism in Italy during World War II. His story doesn't end there. For 35 years after the war, he continued as editor of the venerable *La Parola del Popolo* in Chicago. In their efforts to emphasize middle class achievement, third and fourth generation Italian Americans often ignore the significant minority of Italian immigrants who identified with democratic socialism in the first decades of the twentieth century. As this interview shows, Italian Socialists were an integral part of the Italian experience in Chicago. This interview was originally done as part of incomplete videotape for the Italians in Chicago Project. Because Clemente's English was so heavily accented, the video production was abandoned. Though the interview below has been heavily edited, it remains a far cry from standard English. However, the diligent and patient reader of this piece will be rewarded with a glimpse at the brilliant mind and fervent idealism of Egidio Clemente.

EGIDIO CLEMENTE

I was born in 1899 in Trieste, then under the rule of the Austria Hungary Empire. My parents were from a small little town, Friuli near Gorizia (my father), and my mother from Istria (now Yugoslavia). My father was a bricklayer and in later years, a contractor. He was in charge of construction of buildings, and he was in charge of the people who were working on the building.

I had eight years of elementary school. We went to school from six years old to 14 (eighth grade). After 14, you can choose to go to higher schools. I chose to go to a school which was teaching trades, but not only trades, for example: printer, mechanics,

bricklayer—but also design, the languages and mathematics, physics, chemistry, and so forth. The first year, I failed two courses, physics and chemistry, so I decided to quit school and go to work. I was really interested in printing, and I found a job as a printing apprentice. It was not like it is today. Today an apprentice printer is paid. At that time, there was no pay. I learned the hard way. I worked six months without pay. I do not remember exactly what they were printing. In those days, there were no automatic machines; everything was set by hand. When they came from the presses, you had to distribute each letter of the alphabet, put it back in the proper boxes, the proper kind of types, the different size of types, and the small boxes where the type has to go. It takes time. I had to work. After six months they gave me two *coroni*, (Austrian money). You figure the value of about two liras or five coronis were $1. So for 48 hours of work a week, I had two coroni—less than $1 a week. I stayed there for several months, then they increased the pay. I was able to do the job very well.

I started to have a political view when I was very young. It came this way—I was living in one of the main streets of the city. I don't remember my age, but I was very young. It was May 1. Hundreds of workers were coming down from one plaza to go to another plaza to have a mass meeting, and they were singing with a red flag, and they had also a band playing some kind of song. Later on I found out there were Socialist. It was a celebration of the centenary of Giuseppe Verdi. And so in my mind came, I don't know some ideas why these people, poor people here, are doing this kind of job. I started reading a newspaper, *Lavoratura* it was called, a daily paper, Socialist paper.

Then when I was 14, I joined the young peoples' Socialist League. That group, beside the meetings in the evening, we used play soccer, and it wasn't only that but it was to go to small towns near the city, walking all day long and talking with the peasants of the

place, giving them newspapers, leaflets, and other Socialist propaganda.

In 1914, the first World War broke out. This is really the most important point of my life. My older brother was on a merchant ship, and he left the port of Trieste exactly eight days before the proclamation of the war. The ship was in the middle of the Atlantic when they heard the declaration of war, but instead of returning, the ship went to Canada. Somehow, after few weeks in Canada, they came to New York. My brother stayed in New York.

The 23rd of May 1915, my mother told me to go to the small town where my father was born. The mother of my father was an old lady, and she was scared of the war. The town was just near the dividing line between Italy and Austria. I was supposed to go there and to accompany her to Trieste, the big city, so to be out of the war.

At that time we lived under Austria, but we were talking the Italian language. I went to school in Italian schools; we learned everything Italian. The city itself, the name of all the streets, they were all Italian, the names of the Italian patriots. The city hall, the *municipio*, and the schools were Italian. But if you wanted to go to German school, you had also German school, but they were in Italian—everything was in Italian. I studied German a couple hours a day in the school. Everything else, history, geography, everything else was in Italian.

The 23rd of May 1915, I took a train to go to this small town. About 5 miles away from town, the train stopped. The border was sealed because of the declaration of war, Italy against Austria. So I say to myself, "What do we have to do here. It is only 5 miles. I'll walk to my grandmother's and see if we can get her to Trieste." Suddenly three Austrian soldiers, *gendarmes*, stop me and ask me where I'm going. They were not speaking Italian; they were speaking just in German, or Slovenian, or Croatian, or I don't know. So I told them where I was going—to Trieste. I was just a kid, a 15-year-old-kid, but I had a

tie clip with the colors of the Italian flag and written was "Tripoli." Tripoli was the Libyan capital that Italy in 1911 conquered. Beside that, I had in my pocket the Young People's Socialist League membership card. They threw me in jail. That was about 1:00 in the afternoon. They kept us only a few hours. At about 5:00, they brought us a dish of something to eat. Naturally, I was hungry. I was really mad, I was crying just like little kid. But finally at 8:00, they took us to the railway station. There were about 60 or 70 people. They were people that the Austria authorities were afraid of—traitors or spies, predominately Italians. Security risks. So they took us over there and threw us in a train car. For five days and five nights, we were riding all around Austria. They put us in a big concentration camp that they built near Gratz. There were thousands of people there. After five days, someone came over there and divided who were of Italian origin and who were Austrians, like me for example with Italian lineage, and they took off all the women and children and old people of the Italians. They put them on the train and sent them back to Switzerland and Italy. They kept as prisoner of war the men who were able to fight.

They put us on another train, and they sent us somewhere after several days; finally we reached a place near Vienna. There was nothing there, just a small cabin. We walked about a mile from the station. All around the house was a cordon of soldiers. We were around 100, 120 all together; I was hungry. Other people had food because they knew where they were going. I didn't know where I was going; I didn't have any food with me. They passed me a piece of bread and a piece of sausage, a little salami. One of them said, "Why don't you go in the kitchen and help that woman to cook?" I did; she had a big pot of polenta, farina. So I help her put some coal on the fire; I ate three or four ladles of polenta 'cause I was hungry.

Later on, they put up a fence with the soldiers around, and they built several

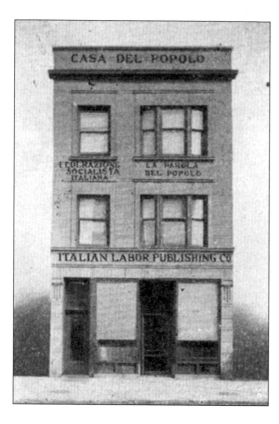

The Italian Socialist Federation did not hide its light under a bushel. This is the headquarters on Blue Island Avenue in the 1920s and Clemente's work place for many years. He recalled this period as a happy one.

barracks for the people who came there from Trenta, from Trentino, from Trieste, from Bolla, and the big cities which today are under Yugoslavia and all along the Adriatic coast.

We stayed there, but we had nothing to do. Someone started the school in French, someone the school in English, someone in Italian, so forth. It was a group of intelligent people over there. They were rich people; they had money, and they had the possibility to live a little better. Not me. I was alone. Nothing, I had nothing, nothing, nothing. And my parents in Trieste, my mother was crazy, she went around, she ran around to try

to find out where I was. And she was crying, what the hell could have happened to me, how did I disappear for so long. I was writing. I didn't have no pen, somebody give me a piece of paper, envelope. The letter got to her after several weeks or a month. They started moving someone to try to liberate me. They asked the congressman from Trieste to find out why I had to be there. A kid of 15 years old couldn't be a traitor. On November 15, 1915, they took me out from there and put me in the Army.

Two days later, we found out that our regiment was transferred. We were going to Russia, but our regiment was transferring to Romania. To fight the Romanians. They put us in those wagons with five horses and 40 men, you know—cars, those railroad cars.

I say to myself, "I'm not going to the front." One day we saw a big city, and the train was slowing down. I took myself off the train. I tried to jump off, but in that instant, an express passed by, and I just had time to get back or that train would have killed me. I didn't want to be killed. So after the express train passed, I jumped from the train. Naturally the train stopped, and they called the Red Cross, and they took me to the hospital.

I reached the hospital the same day the Italians suffered a major defeat. Everybody else was crying victory and so forth; instead I put myself under the covers and was crying, crying not because Italy lost but because the war was going on. I was by myself. I stayed there a week. They got me papers to go to the headquarters in Gratz. A few days later I presented myself at the headquarters.

The Staff Sargent asked me did I want a job. "What kind of job?" I said. "You stay here in my office." "Sure I like to stay here in your office." But that son of a gun, he kept me because I was young and strong. He was sending me twice a week outside the headquarters to the country to look for eggs, butter, bread, farina, and tobacco. He had a natural monopoly over tobacco. He kept me there for several months. Then all the men

65, 55 years old, they got to go back. He sent me back with these people, and so I finished the war. On December the 8th, I arrived in Trieste—1918.

After the war, I rejoined the Socialists and got arrested. They broke my nose, and they took us in jail. I told them, "I was just dancing with my girl." They said, "You are an Italian traitor." I replied, "I was born here and here I stay." He was a Carabiniere; finally he let me go. Then I saw the Fascists, fighting and destroying the newspapers; they burned the Casa del Popolo and the learning centers we had. . . around town. As long as I had my brother in America, I said, "Let's find out if we can get away from here." My father was dead; my mother had two small children. My brother said, "Why don't you come everyone in America?" He sent the money, and we came to the United States, November 1, 1920.

My other brother (a mechanic) left Italy to work on the *Casulich* line; at New York he jumped ship and joined the family at a big house in Oceanside, Long Island, that we rented. I couldn't find a job. I worked for a while in West Hoboken, New Jersey, as a printer, but my mother was very, very sick, and she decided to return to Italy with her sisters. I was alone without a job for over a year—I refused any help. I want to be independent. I was sometimes sleeping in the park on the bench. Finally, I found a job in Paterson, in a textile plant for a couple of weeks. I didn't like the job; it was not paying even the street car. Finally, I found a job reading the paper. They were looking for a typesetter in Pittsburgh, Pennsylvaia. I wrote, and they accepted me, so I went to Pittsburgh. There was already a group of Socialists (during the time I was in New York, I was naturally a member of the Socialist Party). Several times I spoke on the street corners with some American fellows against Fascism, against war, etc. So in Pittsburgh, I joined right away with the Socialists, and with the job I had as a printer, I started going around, and there was a big strike of western

Pennsylvania Miners.

Most of them were from North Italy, Lombard, Trent, Liguria, Emilia. The owners owned the houses where the miners lived, they owned the water, they owned the heating plant, the grocery, everything. They threw the miners out, and the miners were camping in the woods in tents, and I was going there on Sunday. I had *La Parola* with me and *Defense* printed by the miners union and distributed them. I made many friendships. All day, and then I took the streetcar back. At that time, all the small towns around in western Pennsylvania were connected with the street cars. Kingston, where is the big aluminum factory, we organized them. I started working for *La Parola del Popolo* in New York.

In 1926, when I came to Chicago, I saw a city of dirt—except the boulevards built by Bill Thompson. But the clink-clank, clink-clank of the streetcars was really getting on my nerves. It was really miserable. There were no doors on the streetcars, and during the winter they were so crowded that in the back of the streetcar, we were shivering. I came here in Chicago because the Italian Socialist Federation owned a printing plant at Taylor and Blue Island, and they needed a typesetter. So I came to Chicago and was working on that corner. A year or two before on that corner, five brothers were killed (the Genna Brothers, gangsters).

I saw one thing which put my mind against the establishment—the daily newspapers were publishing the names of the people accused of some crime, and they would put in parenthesis "Italian" or "Negro." That was something which we fought very bitterly against the *Chicago Tribune*, *The Herald American*, *The Daily News*. Chicago really was a ghetto for my part. *La Parola del Popolo*. . . Italian Socialist Federation was an organization, and the Socialist Party, it had its headquarters here in Chicago. All the Socialist Federations—Finland, Germany, Polish, Greek, Czechoslavakian, Yugoslavia federations were organized, and they

CONSOLATO GENERALE D'ITALIA

CHICAGO ILL. _____ 13 Maggio 1930 VIII
INSURANCE CENTER BLDG.
230 SOUTH WELLS STREET, SUITE, 1106
TEL. WABASH 5320

26 Aprile 1930

N.º 5144

Pos. A.-3

CASELLARIO POLITICO CENTRALE

49032

22-GIU-1930

OGGETTO

CLEMENTI Egidio fu Angelo e Notizo Maria
nato a Trieste il 2-9-1899- tipografo.

ALL.

Signor Console Generale,
Chicago.

Con riferimento alla nota N. 996 del 26 Marzo us.
ho il pregio d'informare la S.V.I. che il nominativo e-
marginato residente in Chicago, al N.1144 N.Avers Ave. è
un attivo anarchico e si occupa della propaganda antifa-
scita, contribuendo spesso con somme di denaro.

Con distintissima considerazione,

Il R. Console Generale

10 GIU 1930

R. Consolato Generale di

New York

e per conoscenza:

al Ministero degli Affari Esteri

Affari riservati Roma

al Ministero dell'Interno

This letter proves that Consul General Giuseppe Castruccio's agents were spying on Clemente and sending reports back to the Ministry of Foreign Affairs classifying him as an anarchist and an antifascist. These letters prompted ominous visits to Clemente's mother in Trieste from Fascist officials. Castruccio was the Chicago organizer of the Balbo Flight.

belonged to the Socialist Party. Every federation was doing Socialist propaganda in their own languages among their own people.

The Italians were doing the same thing. We had a weekly paper, *La Parola del Popolo* (PDP). For years, the shop was a cooperative. It was established in 1915, by Dr. Molinari, well known among the poor people of Chicago. No matter what kind of race— Italian, German, American, colored people— he was paying his own fare to see people and sometimes to give them money to buy medicine. He was the editor during 1915, '16, '17, and he built the printing plant. At the end of the war, 1920, they bought that building completely.

It was a three-floor building; the first floor was a shop, the second floor were the offices of the federation, and the third floor was rented. We had two linotypes but no big press to print the paper, so we were sending it out to a Czechoslovakian printing plant. I was working just like any member of the staff, but nevertheless I was writing and publishing a column called *"Dalla Porcopoli,"* from the "Pork City." My duty was just to look and to check most of the Italian societies. Many of them were infested by criminals, and they were under the heads of Capone doing the work of moonshine or transportation of liquors, whisky and so forth, because during that time it was prohibited. They were working under his auspices. I won't say the name of the society because many of them (members) are still alive, and they are very nice, and they changed the names, but they are good people working now—nice, very good. I was exposing those things in the column. The paper was involved in Socialist propaganda; we were debating the Fascists, and we took a position against Fascism.

The Italian government, the Mussolini government at the time, tried to conquer not only the parochial schools, but also the middle class. Besides the people with a lot of money, they were trying to take them into the Fascist philosophies, with money and with propaganda. The Italian Consul was just an agency of the Fascists. I'll give you an example. Today, the Italian Consul is served with only five people, and they have jurisdiction of 11 states. At that time, instead there were 20 people working in the consulate. I have a document I can show, the four or five reports that the Italian Consul was checking on the people who were fighting Fascism. And they sent those reports to Italy to the *ministero degli affari esteri*. They were going and looking for me and trying to give trouble to my mother or my family, which I left in Italy. They said that Clemente is an anarchist, anti-fascist, and so forth. He's doing this, doing that. The Carabinieri in my hometown went to see my mother, asking her, "Where is your son?" Your son is a traitor. My mother wrote me, "Please don't do anything because they come here so often that they get us scared." They were putting pressure on our relatives in Italy. We (opposed) fought the Ethiopia war that we fought (opposed) when Italy declared war against America in 1941, we took part with our paper and our magazines; these were several [radical] papers in the Italian language in the United States.

We were very, very active trying to save Sacco and Vanzetti. We had almost unity among the old radical groups, because there were in Chicago communists, socialists, anarchists, syndicates, and so forth. We had several Italian labor organizations, locals, the Amalgamted (clothing workers), and the International Laborers Union. We were all united, and we had speakers from New York, and we made demonstrations in big halls on the South Side and North Side and even in Kensington and Chicago Heights. All around the area, we were trying to collect money. I took part just for that year here in Chicago.

But if you ask me the question of Sacco and Vanzetti, it's a different story. The De Felicana, who was a good friend of Vanzetti, was very active. In the last issue of *La Parola del Popolo,* I published an article in Italian

Giuseppe Bertelli was the founder of La Parola del Popolo *in 1908. He was a forceful personality who stood up to censorship during World War I.*

This cover of the 70th Anniversary issue pays tribute to the many names and mastheads that La Parola *had to adopt in its battle to speak out in the United States during World War I.*

and English about the papers of Feliciani, who was the treasurer of the committee for seven years; he turned all his documents over to the library of Boston. And even Vanzetti's sister came from Italy to participate in that affair. The defense for the liberation or to show the innocence of Sacco and Vanzetti did everything that was possible. But it was against the prejudices, the hysteria, that there is no use now to go through.

The day Sacco and Vanzetti were executed, I was crying like a baby. I was coming out of a show with my two children and saw it about 11:00 in the evening, and my son said, "Daddy there is something important on the radio." They said that Sacco and Vanzetti will be executed in a few minutes, and I felt really very bad [breaks down crying in the interview] because it was a disgrace of justice. I have several books, pros and cons on Sacco and Vanzetti. By reading those books, you will see that there was a hysteria against the Italians, against the radicals at that time.

The death of Sacco and Vanzetti has been a tremendous shock for those activists in the radical movement, but little by little it disappeared. Now you will find very few people, a very small percentage of the Italians who are in the U.S. who know or feel like I felt for Sacco and Vanzetti. Everything disappeared—the wheel of nature, of civilization goes around and round. Even Mussolini was against the U.S. courts. And he asked for a pardon for Sacco and Vanzetti from the president at that time. Even Mussolini, the Fascist, was interested in Sacco and Vanzetti. That was the only time we agreed with Mussolini.

Living conditions Chicago 1920s—wages were low, $1 an hour. We were paying $25 rent for five rooms on the Northwest Side. We had a group here in Chicago—120–130 members of the Italian Socialist Federation. We had a branch at 7300 West Grand Avenue, a small house and store, and behind the store was a big hall. We'd go there almost every Saturday, dancing, drinking beer, picnics on Sunday at North and Grand Avenue where the Fontana d'Oro is now. For picnics, we used to buy one or two barrels of beer from Capone. It was Prohibition, and on each barrel we were making $25 or $30 profit, and every penny we made was given to *La Parola*. The paper cost us only $50 to set up the type for four pages, $15 for printing and paper, and we had to pay the administrator. With $100 a week, we were going good, but we had to make the $100. The subscriptions were only $1 a year. At each meeting we had, everyone would pitch in their 10¢ or a quarter to give it to the newspaper. But then we were happy! Many times we used to go home after 12:00 (midnight) singing songs, walking, and making merry.

We were happy. Every month, we had serious political meetings in which we discussed the question of the American movement, and we read the bulletin from the headquarters of the Socialist Party. That was the duty of the secretary of the federation, which I had been from 1929 up to 1942. I had to do all those translations in Italian and send them out to all the branches in the United States.

In the 1920s, we had a correspondent from Paris. Professor Bertelli was the editor; we had translations from Oscar Heminger publishing from Missouri *The New Guardian*. It was a fighting newspaper. We had five branches in Massachusetts, two branches in New York, one branch in Washington, branches in Michigan, Missouri, St. Louis. They were sending us communications that we published. *La Parola* was a national paper, as it is today, always national. We reported the news from different states. During the elections, we were taking part only to support the candidates of the Socialist Party.

During the Depression, we worked among the unemployed. We were very active in Chicago. The Chicago branch of the Alliance of the Unemployed was one of the most

active. We had hundreds of Italians, but we didn't divide the group according to languages (the way the Socialist Party did.) Some spoke in Polish, some spoke Italian, and some spoke English. We tried to keep all of the unemployed together in demonstrations and to force the city government and state government to help. We took a very active part as Socialists. We made a big mistake as a philosophy not to show the unemployed what will come after they went back to work. The 50 million unemployed, as the war started in Europe, little by little, started going back to work in the factories, and they forgot all about the Socialist philosophy. Instead of keeping unity among all those groups, we let them go. If they got a good job, forget about it —they forgot all the years they were unemployed and hungry. That was one of the biggest errors that the Socialist Party ever made. We should have tried to keep them together!

Members of the executive committees of the Socialists were already members of the union and union leadership—the Amalgamated Local 270 was all Italian. The officers were doing their work as Socialists in the union. The same thing with the International Ladies Garment Workers, the Shoemakers, the Bakers. Myself, I left the labor union work to those who were already in the Bakers' Union.

Usually there were many, many baker shops, and they used to send bread home (delivery). They had like subscribers. Everyone bought a loaf or two for 5¢ each. Every bakery had trucks and drivers. The drivers were paid very little, and the baker shops were under the control of a gang, racketeers. On each loaf of bread coming out of the oven, the owner had to put a label, a small sticker, just like a stamp, and each stamp cost one penny. They had to buy those stamps from the gang, the association, so-called. If the truck of bread was stopped by these people, and they didn't find the label, they would throw all the bread in the street, destroy the bread. We had the drivers who

wanted to organize themselves, and they came to me at the Socialist Federation asking me if I can help them to organize the group—60 or 70 drivers, all together, all Italian. With me was a very good friend (paesano), Giovanni Pippan. He organized the bread drivers, but the label was still there. And he told the owners, "It would be nice for you to be organized, and then we will apply for a charter from the AFL to have some support, and then you can take off the labels, which cost you hundreds of dollars, and then we can fight the gangsters, the racketeers." And then they were almost saying "yes." It's no secret that one of the big bakers, still existing now, was trying to buy up the small bakeries to form one big bakery. For his efforts, Pippan was murdered.

In the 1930s, the newspaper was a popular newspaper. We tried to serve the workers, members of unions. The newspaper was printed only in the Italian language, we were printing 4,000–4,500. For May 1, the holiday of the world radical movement, we always printed a couple thousand extra copies and sent to the branches to distribute to non-subscribers as a propaganda work for Socialism. All over the country—from the Atlantic to the Pacific, from Maine to Florida—not in Italy because of the Fascist [regime]. . . but in Paris. The greatest circulation that we had was during the Spanish Civil War, because many of our members went to Spain to fight against France. From New York, Massachusetts, some from Chicago volunteered for the Intergovernmental Brigade—the Garibaldi brigade. Lt. Pacciardi was the commander of that brigade. He fought against a brigade of Italian Fascists. Both sides, Italians. And in my 70th anniversary issue, I have an article with a picture of what the Italians did in Spain.

We are against any war, we want prosperity, we are against armament and militarism. We are for democracy. . . .

The First World War, we were against the war. Against the U.S. government, because

we know. I wasn't here, but as I read *La Parolo* from that time, they were completely against the war. *La Parolo* had to change names several times during the war because they were suppressed. The state department suppressed *La Parola*. The real name of *La Parola* is "*La Parola dei Socialisti*." They had to change to *L'Avanti*, *La Sciocola*, and several other names, and at the end of the war they changed to *La Parola del Popolo*, as it is now. During World War I, you could not publish a paper against the war. It was suppressed by the post office and by the state government. Instead, during the Second World War, before America joined the war, the Socialist Party was against the war. We, as Italian Socialists, declared in our convention that we are supporting the war of a democracy against the Fascists and Hitler, because we knew that Fascism and Hitler were the cause of the war. We had to get off the National (Socialist) Organization. When America entered the war, I don't know how or which way the American Socialist acted, because at that time I went to Europe as a volunteer. As a federation, we withdrew from the national organization.

We had a Sunday meeting on Chicago Avenue near Western, at a big theatre, at 11:00 in the morning. Judge Quilici was supposed to be the chairman of that meeting. He came late. When he came, he was terribly upset. He went up to the dais and said that the Japanese bombed Pearl Harbor. We were just shocked and didn't know what to do.

The response was unanimous that we are in a war, that we had to go to war. Hitler had already conquered France and was threatening England.

In that time, there was no CIA, so General Donovan, a friend of Roosevelt, went to the president to organize an intelligence group of Americans of origin of several nations—French, Italian, Korean, Serbian, etc. The idea was accepted by Roosevelt, so General Donovan was put at the head. They put the name OSS, Office of Strategic Services.

Several months after the declaration of war, I got a call from New York, asking me to have a meeting with Professor Borgiese. He was the outstanding professor of Italian Literature at the University of Chicago. He was Sicilian. I organized a meeting with Quilici, plus Valenti and Corvo; we had a meeting with Borgiese at his house. They had some tips of intellectual people who were still in Sicily. He (Borgiese) gave several names of Sicilian anti-fascists. Valenti and this fellow told us that they were planning and working to invade Sicily. It was two years before the invasion. Later they came to have dinner at my house, and Valenti asked me, "Are you willing to join this group." I said, "I'm not Sicilian. What the hell! I've got a family; I cannot leave my family alone. I am just willing to do any effort for the war to fight the Fascists, but I can't come over there." "No, no," he said, "It is not only Sicily, it is all Italy." I said, "Put my name down and we'll see, later on."

A few weeks later, I had a call from a fellow who's still living, in New York, Brennan, who was a Vice Consul in Italy for many years— he's a very experienced diplomat. He said to go to Detroit. So I went to Detroit. And there I found several offers—all Socialist. He told me, "If you want to come, we will take care of your family. In case something happens, we will take care of them forever. You will be paid so much." It was dangerous; I accepted. So I came back to Chicago. Later on, I received an order that right away they'd pay me $10 a day. They put me on the payroll. I was 43 years old. My wife said, "If it's all for the cause, and if you want to do something good, why not?" The most important thing is the political point of view. So they gave me the order to go to the headquarters of the 5th Army, and I received all the shots. . . I didn't care about the money.

Count Carlo Sforza was one of the outstanding politicians of Italy. He was the Italian Ambassador to Paris before Mussolini took over. He was the only one, the only one who resigned his post [in protest against

Mussolini's accession to power]. He came to the U.S. He was a friend of many in the Roosevelt administration. He came to Chicago, so I invited him to lunch and told him, "I have this chance to go to Italy, etc." Sforza said, "Clemente, I think that it is very good. You have to put some kind of question to the government as a volunteer." Beside me, there were five from Chicago. The question is this—that Italy will not be dismembered. The colonies of the Italian will be treated the same as the colonies of other nations. No discrimination, no monarchy, and no interfering in the elections of the Italian people. . . . That was really what we wanted as Socialists. When we had another meeting with Brennan, we told him, "We'll join. We'll do everything even if we are to lose our lives, BUT we want these promises." Twenty-four hours later, we had the answer that Roosevelt promised us what we are asking for. There was nothing in writing, but we accepted the word of the president.

I left in 1943. We had two months of training in Washington. My wife didn't know where I was! Once in a while, I would call her on the telephone and tell her, "I am here, don't worry about it," and she received the check from the government. Marino Mazzei, who I worked with, didn't know where I was. He was working at the shop, and Clemente disappeared—where he went, nobody knew anything. My son, one year earlier, had joined the Army, and he was sent to the Pacific. He came out as a sergeant. I left the U.S. in May 1943, on the *U.S.S. United States*, the biggest boat the U.S. had. That boat carried 8,000 soldiers all together. We didn't have any escort. No submarines. We just went through for five days to Casablanca, North Africa. From there we went to Algeria; we stayed one week. In the meantime, there was the invasion of Sicily. From Algeria, we went to Biserta and from there we went to Sicily. Sicily was already conquered, except the part at Catania near the continent. We disembarked in Gela to Caltanisetta to Palermo. In Palermo, we stayed several months. We had three missions: first, there was a group of Sicilians from Detroit— gangsters, racketeers who were friends of that fellow who was in jail in New York who

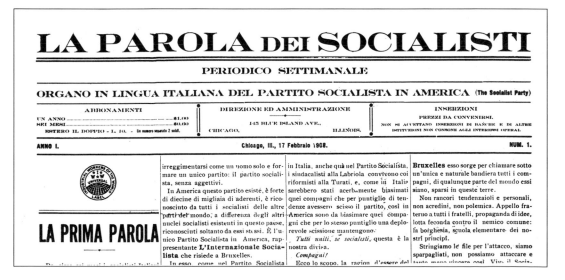

The first issue of La Parola die Socialisti, *later* La Parola del Popolo, *is shown in February 1908. It announced itself as a weekly organ of the Socialist Party of America dedicated to the tens of thousands of Italian-speaking adherents of the Socialist cause.*

Artist Latterio Calapai created this wood art depicting the difficulty and the dignity of hard manual labor celebrated by the Italian Socialists. (Artist Latterio Calapai created this wood art depicting the difficulty and the dignity of hard labor celebrated by the Italian Socialists.)

promised that all the gangsters of Sicily will help the American Army. We had a group of five or six of them, and they tried to go to the other side of the line. The Germans had a line close to Catania and Messina blocking passage to Calabria. The gangster group came back without anything because they were afraid. The colonel, Pantaleone, was really mad. He was in the First World War (as an Italian officer)—went to Fiume with Gabriele D'Annuzio. He came to the U.S. and became a lieutenant colonel. General Clark gave us a *carta blanca*; we could go any place we wanted, do what we wanted, as long as we did something good. When we sent out the first mission and they came back empty handed, he was mad.

Pantaleone asked for volunteers to go with him to the other side overland to arouse the population behind enemy lines. He chose two, a sergeant and a paesano of mine. They went out and picked up three paid civilians. They went through, but they were ambushed. They tried to fight, but it was impossible. The civilians were shot on the spot. And the colonel and my paesano they took as prisoners. The sergeant succeeded in returning. We learned later that the Germans killed Colonel Pantaleone.

In September, we took over a Villa, Villa Maria in Palermo, and there I was in charge of food, cleaning, everything. They sent me on a mission to Capri, Vento Taine, the islands near Salerno, September 8. During that time, the Americans disembarked on Salerno, and we were looking for Mussolini. They told us that Mussolini was on a small island near Naples, in the Gulf of Naples. I stayed there one week. Then we went to Brindisi. I had the order to go to Trieste with two other people—the *telegrafista* (radio man) and my helper. I knew Trieste. Our commander asked permission from Tito to pass through Yugoslavian lines in the Adriatic to reach Trieste. He wouldn't let us go, because he was planning to have Trieste for Yugoslavia. That's another mission that didn't materialize.

It is a long and complicated story. I can't explain it in just a few words. Many anecdotes I just left out. After being excluded from a mission to Venice, I was so mad that I asked my commander to let me go to the front, "I want to go fight, not stay over here doing nothing, keeping track of how much we spent for a pound of bread. Let me go out!" They organized in the OSS a group of Germans, Austrians with American professionals in history and psychology—the name was Warner. They organized in the OSS a group called the MO, Morale Operation, to try to break the morale of the German troops. But they needed a good printer. They sent me to Naples with this group. I joined them; I found a printing plant that had been destroyed, but there were several type cases open and one press. I took it over at night, and I was working there every night. I set type for propaganda against the Nazis to break the morale of the Germans. Everything was in German. I worked there for a couple of weeks. Then came preparations for the invasion of France. The order was for us to move to Algeria and prepare the work for the invasion of Marseilles. We went to Algeria, and we made a deal with the proprietor of a printing shop to let me have the printing shop all by myself after they closed for the day at 6:00 p.m.

But the order was also to keep my 45 because. . . at that time many Algerians were Nazi. I worked on one linotype with a French keyboard and typing in the German language. I got a radiogram from New York everyday, and I printed a big newspaper, the *DAS Neve DEUTCHLAND*. "The New Country." It was a new automatic press. I never used it before, so I closed the forms; I put them on the press; I cut the paper all by myself during the night and let the machine go vroom! vroom! vroom! I made several thousand, badly printed because I didn't know how to use the machinery. The next morning, they came to pick up everything and put it in a bag, and they sent a few copies to Roosevelt, because it was not necessary to

have a job well done. It was necessary to have it rough, with different unmatched types, dirty with ink, something which you would throw away. They would pick it up, make a nice package, and put it in the airplane. In the evening, the airplanes were going to France and dropping the papers behind German lines, and Roosevelt sent us a letter of congratulations. . . and I was crying. I stayed there [Algeria] for several weeks.

July 8, 1944, I went to Rome. In Rome, there's another story. The work we did in Rome was for Resistenza, for the Guerilla anti-fascists who were fighting up north against the Germans and Fascists. The order they gave me was to go around the city looking for a printing press. I found one on Via Crescenzo No 2. Just behind Castel Sant'Angelo near the Vatican. A shop with two linotypes and several presses and over 20 people working. I talked to the owner. He was not working there that day on account of no electricity, and he had another shop in a different part of the city. I offered to rent the shop and to be responsible for everything that was going on in the shop. We decided to give him L48,000 a month, and I promised to keep all the workers. I called the people together, and I told them, "From now on you are under the jurisdiction of the United States Army, and I am your boss". And I said, "What is your hourly wage? From this month on, everyone has double pay. But everything that is going on here you have to keep a secret. You don't have to say a word to nobody." There was a problem of transportation; there was no electricity, no buses, we didn't have electricity during the day. I arranged with the power company to close off all the electric circuits at 11:00 at night until 7:00 in the morning and let all that electricity come to our printing shop. In the meantime, we sent out a call to Washington to send us a generator. So I told the people (workers), "Now you got to work from 11 to 7, eight hours." There was the problem of transportation. The outfit was not able to have a jeep or a car, but they organized to get two taxi cabs. One taxi cab was at my disposition. I rented a room in the third floor of the same building—the taxicabs were coming there at 9:00 in the evening picking me up, and we went all around the city, picking up the workers and bringing them to the shop. Those who were living nearby walked. I was very grateful to those people because they did a beautiful job. I had rations for five people so I could feed the German writers who came every night to give me the print orders and make the corrections on what we were supposed to print. Since they didn't eat, I had five extra rations everyday and a big loaf of bread. So I gave it to the workers. In the evening, the workers were cooking there, and they had a good dinner. That's the reason they did so well and did really outstanding work.

The Senate in Washington was questioning the money we were asking for to support the OSS, and they organized a group of senators to come to Rome to find out what we are doing. One day, Mr. Warner called me on the phone, and he said, "You will have a big surprise tomorrow. Nimitz the Admiral of the Mediterranean Fleet is coming here, Lt. Col. Gardi (the right hand of Donovan) and three senators."

They came. I saluted them. I was in civilian clothes with a GI jacket on. I showed them the printing shop, the presses, and the people working, and I showed them something else. There was a room, double the size of the print shop with big tables, and piled up all around was the material which we had printed—thousands of different pieces of propaganda against Nazis. Then I showed them the chart of all the jobs we had done—handbills, newspapers, and many other things, to propagandize against the Nazis. When they saw all those things, they started talking. I was in the doorway laughing because I knew that they were counting how many hundreds of thousands of leaflets of different kinds we were sending out. When they left, everyone shook hand,

Clemente smiles as he waits to greet Italian President Sandro Pertini. The two had an affinity because both were Socialists and both worked during World War II to overthrow the Facist regime, c. 1980.

and they said, "Mr. Clemente, congratulations."

We thought that the weakest link of the German empire was Austria. They were easier targets to break out from Hitler. Our propaganda was against the Nazis of Austria. We used a movement that we named "Sauer Kraut." In Foggia was a group of aviators who were expert at bombing trains. We had an office in Geneva, Switzerland; we got the telephone books of the most important cities of Austria—Vienna, Gratz, Linz. We used German typewriters. I hired a dozen young ladies. We chose from the telephone book the names of the banks and big corporations of Vienna. I had to falsify

(counterfeit) the German postage stamps. The girls were printing the names of the outstanding Nazis from Vienna with envelopes that had to have (counterfeit) cancellation stamps and mail bags, and we had the timetable showing when the trains went from Gratz to Vienna. We printed on onionskin. The message was in German always against Hitler; he was losing the war. That Hitler was living in Bavaria, that he had committed suicide, or was contemplating defeat, propaganda. . . how many of German and Austrian boys were being killed while the big shots of Germany were raping the women and children on the home front.

It's pornography, see there are no men in

there. They are just lesbians. [Clemente at this point displayed six pornographic "eight pager" cartoon drawings with slogans in German] and headlines saying "five million will be dead, for what?" The propaganda was printed on onionskin, so you could put a lot of them in an envelope. When we knew that a train was going to Vienna, say from Gratz, the aviators of Foggia were ready with one or two airplanes to bombard the train. In Foggia, we had another group who were putting the date with the postal stamp on the envelopes, which they put in the (counterfeit) mail bags. When the airplanes dropped bombs on the train, they also dropped the mail bags.

There was an order by Hitler that (recovered) mail bags must be picked up right away without opening them because it was important to keep (mail) communications flowing. The people in Vienna were receiving from the mail the letters which we printed in Rome with (the return address had) the name of the banks on every envelope—the Bank of Gantz for example—and it was addressed to people in Gantz listed in the telephone book. Another question? How about the type—to have the same type? That was my problem. I had to go to several places to find the type, to match the type they used. The Vatican helped me many times with the kind of type the Germans used. In the Army, in the field, they had documents—death certificates. We copied the front page exactly, and on the other side we printed propaganda against Nazis, and then we would throw out (of airplanes) the documents on the camps where the German soldiers were. If they saw a death certificate (on the ground) they would pick it up and on the back was the propaganda. All our appeals we did were trying to break German morale.

They were supposed to be counterfeited so as to appear to be printed in Germany and not from us. For example, we knew that Hitler ordered in 1944 some grain/food to be taken from Italian depots and brought to Germany. So we published it in German and Italian, both languages. Also we made propaganda in Russian and Czechoslovakian languages, because the Germans brought prisoners from other countries to the Italian front to work. We sent the POW's messages in their languages urging them to escape even printing for them "passports" to show to the English and American Armies to pass through (the front) without any trouble. We were sowing seeds of confusion behind enemy lines. In Milano, there is a Museum of the Resistance, and in 1968, I brought them all the things which I printed during the war to demonstrate the success of our work.

I was in Rome nine months. One Sunday, toward the end of the war, around 9:00 or 10:00 in the evening, I called up and the chief said, "You have to come right away, it's something really important." So I went up, and there was a manifesto poster in German that said, "Today I received the news that Hitler passed through the American front lines and is now a prisoner of war. All the German troops are under the command of myself, Mussolini, etc." So I went back to the shop to print this (counterfeit) poster. We had to print at least 50,000, so I made four forms, and in the morning by 9:00, everything was finished. That poster was never used because the war ended a few days later.

Maria Valiani

To Oakley and "Traviata"

"We came on a boat third class and had to sleep in hammocks in the basement of the ship."

Valiani appeared as a guest on the "Ciao, Italiani" radio show produced by Rose Ann Rabiola at WUIC in the 1980s.

Maria Valiani's narrative focuses on family life in Italy before emigration. Her description of the difficulties of farm life in northern Italy is filled with the telling detail that vividly connects the modern reader to the past and creates an understanding that surpasses the facts. Her description of the Atlantic passage in the "basement of the ship" and her confusion of "sale" with salt are colorful vignettes that capture the profound and the trivial aspects of the transit from one culture to another. Her description of the joy that the Saturday Metropolitan Opera radio broadcasts brought to the Italian households across the nation well illustrate that Italian immigrants brought to this country rich cultural traditions, as well as their strong backs and an aggressive work ethic.

THE STORY OF MARIA VALIANI

as edited by Ann Sorrentino

MY EARLY YEARS IN ITALY

I was born in Pendona, Italy—a little town on a hill above Viareggio. It is in the Province of Lucca, in the region of Tuscany. Because our home was on a hill, there was not enough land to build anything that spread out, so they built four or five houses on the hill that went straight up like apartment buildings, only they had just two rooms downstairs and two upstairs. In our family, there were eight children, and we all lived in these four rooms with our parents. There was no running water in our house. We had to go quite a distance to get water in flasks. There was a man who had built a place where he collected water that came down from another hill. He rented this place to the women in the town to wash clothes. He would fill it fresh after every washing. My mother washed about once a month, and the clothes were dried on the grass or bushes. I don't quite remember what she did in the

winter. I imagine she washed a very few times. Still, we were healthy. I never saw a doctor, but I can't say the same for my older brothers and sisters. My mother told me there was a time when typhoid hit the town and spread very quickly. She had all five children with typhoid at one time. They managed, but since I wasn't born yet, I don't have any memory of that time. They're all living. They were big boys—five brothers and three sisters. It wasn't easy—but they did it.

My father never went to school, just some evenings when a man with some education taught him the letters and numbers. He went to work when he was seven. But just because he didn't go to school doesn't mean he wasn't smart. He worked as a lumberjack in the mountains, cutting trees to make boards, which were used to make boats. In Viareggio, there was a harbor where they made boats. He was so smart he could measure the trees and cut the boards in such a way as to make use of every board. Sometimes he made wine barrels. If he made a barrel, not even one glass more of wine would fit in it except for what it was measured. He was so perfect in his work. He used to come home about every 15 or 20 days, bringing his dirty clothes. My mother washed and cared for his clothes while he was home, and in two days he would go off again, clean clothes under his arm, walking up into the mountains because there were no trains to take him there.

My mother never went to school either. She was taught in the evening also by some people who could read and write. She raised eight children and taught us our catechism at home. She knew all the questions and answers, and when she died at age 75, she still remembered all the questions and answers in the catechism. They were good parents.

Well, I said before we lived on a hill. The way I can best describe, it was more or less like a pineapple, a pineapple hill. There were lots of hills right next to it. It wasn't that it was only one hill; it was like a chain around

Viareggio—the back part of Viareggio, because we overlooked the Mediterranean Sea. On one side of this hill, it was all olive trees, one side was all grapevines for wine, another side was all chestnuts, and the backside was like a little forest of pine trees. It was from here that we got our only entertainment of the summer. It was from this place on our hill that we came to pass our time as we watched the boats coming and going on the sea. It isn't a big town. There were about five small towns all in a line that formed a horseshoe and made a beautiful view. About three years ago, I went back to see my town with my daughter. She loved it. As we rode up in the bus from Viareggio to go to my hometown, it was such a wonderful pleasure to see everything green, while the bus went winding around up the hill. The little church was still there with the steeple; when the bell rang, everyone knew exactly what day it was. There are hotels there now—and beautiful restaurants in those little forests like nightclubs. It was just beautiful. But it wasn't that beautiful in my time. I mean it was still beautiful to us because it was our home.

In our home, I remember it was always my mother who did everything around the house because my father went to work in the mountains. She also was the one who looked after our school workbooks to see how we were doing. Once when one of my brothers came home with his workbook with writing on one page going one way and the next page upside down, she marched right over to the teacher to show him that he was not careful enough in watching how the work was being done. She reminded him that she expected her son to be taught the proper way. As the family grew, some of the older children began to work outside of our home. The stronger ones went up in the mountains to work as lumberjacks with my father. Others worked down in the harbor of Viareggio, unloading the boats, and some of the others worked shaking the olive trees when they were ready to be picked. I was the

Maria Valiani is pictured at age 19 in 1921. As a seamstress, she had access to stylish clothes.

youngest and stayed home with my mother. When I was four or five years old, she would bring me out with her with a little sack to

help in picking olives. After they were all picked, she would separate them. The best ones were put into a barrel to be cured in salt water for our winter eating. Those which were a little crushed or too ripe were brought to the mill to make our own olive oil. Olives were our main food until they were all gone. While the olives ripened, we had chestnuts for our meals. We had them boiled, roasted, or sometimes she would crush them to make a chestnut gravy.

When it rained, she could not go out to get wood to make a fire in the fireplace. Without a fire she couldn't make the polenta, which we ate often. (That's cornmeal mush.) She used to make bread once a week—great big loaves. If it got stale, she would rub it with some olive oil and garlic. In America, everyone thinks garlic bread is the greatest thing. I ate it way back then as a little girl in Italy. Sometimes there was a little sugar sprinkled on the bread, sometimes she would rub a little tomato on it, and we would

Maria Valiani poses in front of her home at 2334 West 24th Place in the Oakley neighborhood on a wintry day in the 1970s.

go out barefooted and happy to eat our bread in the sun. I never drank milk. The only milk I ever had was when my mother nursed me. At our table, it was wine and water for everybody.

My grandma was living with us. She had her own apartment. We were always together. Sometimes Grandma would go down the hill, near the water, with stones that she gathered; she would build a wall. In a little while, grass would begin to grow, and then there would be little holes that would get wider. Before you know it, there would be snails in these holes. Grandma would bring up a pail full of snails and soak them in saltwater. The next day she prepared a delicious meal of snails and polenta. Today, snails are considered a delicacy, and we were raised on them. Grandma did the same magic with baby eels she brought up from the small ponds in the hill.

When my mother had a little money she bought a sack of flour, a sack of cornmeal, and about one-fourth sack of sugar. Sugar was only used for Christmas and Easter. Then, she would make little dolls from cookie dough and decorate them. Other times, when they were in season, we had fruit. She would buy the fruit because we didn't have our own. We had fresh vegetables all the time because they were found growing wild along the foothills. We had dandelion, asparagus, and mushrooms. We also had chickens, and she kept a rabbit in our basement. It had to be an occasion for us to have chicken, because it was important to keep them for eggs. Once in a while we had an egg, and if someone got sick, maybe they would kill a chicken for soup. I can't say we were bad off, because we were never hungry. Everything we ate was fresh. Looking back, I think that's what kept us strong. We had fresh air and no pollution. That's it. We lived well. We had our own home, our own trees, and sometimes when my brothers worked for people who had larger pieces of land, they would give them olives or potatoes to take home. With all this and the

celery and lettuce my mother managed to plant in between the trees, we always had enough. Sometimes when I thought about how we lived I thought we were poor, but now I know we were not.

That's how we lived, worked, and ate, but I remember playing too. We played in the front yard of our house with the other kids. . . hide-and-go-seek. . . sang songs we learned from our mothers. . . *O, Solo Mio* and *O Marie*. . . and other little songs they taught us. My father was hardly ever there. My mother, sisters, and friends played in this yard. It was not very large, and it wasn't paved. . . just a dirt ground. We made our own little signs in the dirt, and we threw little stones like hopscotch. We were happy.

In 1907, my father came to this country. By this time, some of the others were already married and on their own. The only ones left with my mother were my grandma, one brother, my sister, and me. When he first came, there was a Depression and could not find a job and could not send for us. Until he did, he told her to see what she could do to help herself a little. It didn't take her long to get started. In the summer, she went down to Viareggio to do housework for some rich family. She also found work for my brother, who was only 11 years old. He was a bellboy in a hotel. My sister was about 15. Viareggio gets lots of tourists in the summer, so she found this nice captain of the Army who was on vacation with his wife. They had a child, so my sister was hired as a baby-sitter for the summer.

My mother also went to work in a café— washing dishes and cooking in the kitchen. She'd leave me with my grandma on the hill. In the fall, she would come home and with the money she earned, she bought a little flour, a little cornmeal, and a little sugar. If sheets or towels were needed, she bought them. She even managed to buy a little cloth to make dresses. These were sewn by neighbors in our town. So she worked, and we waited for our father to send for us.

When I went to Italy a few years ago, I went to eat in that same café in Viareggio. . . where my mother cooked in the kitchen. Beautiful Café Margarita. . . Viareggio was beautiful. My eyes kept looking toward the kitchen, thinking, I am here now, enjoying a beautiful dinner with my daughter in this beautiful restaurant where my mother once worked in that same kitchen.

COMING TO AMERICA

The call finally came, so we came on a boat third class and had to sleep on hammocks in the basement of the ship. We were on the sea for two weeks, I think. When we ate, we would go up to the dining room. While we were on the sea, there was a very bad storm. I think it lasted about four days. They had to put up ropes for us to hold on to, or we would fall in the water. We couldn't use the dining room. They gave us a sack of tin dishes—and we'd go for our food. Then we had to sit down on the floor and try to eat. The big wind blew everything into the water; we had to go for another set of dishes and try again. The storm was so bad that the boat was tipped to one side, almost touching the water. We were all scared. The rest of the time after the storm was over. . . everything was fine.

When we came to New York, it was Christmas Day. They did not unload the boat on Christmas Day, so we had to wait. They put us on a small boat and took us to Ellis Island. We passed the Statue of Liberty. They asked my mother where we were going. She told them Chicago. They put a card on her that said Chicago; they put a card on each of us with the same thing. They put us on a train to Chicago. That is where my father had come to find work and a home for his family. We traveled for two or two-and-a-half days, I think. This was 1911. As we were crossing from New York to Chicago, we spent a lot of time looking out the train window; we saw a lot of ugly wood, wooden houses. We always had stone houses in Italy. We never see

wooden houses over there. My ma says, "What kind of house is that? People live in those houses?" They were ugly, especially on the route of the train—all ugly cottages. She said, "Oh, I'm sorry we came here." She was confused. She said, "What kind of a. . . my husband called us to come here?" It was worse, our little town was better. We could see beautiful Viareggio, the ocean. Then my ma says, "Mama mia, how we gonna live over here? What kind of place is this?"

Another thing we saw were quite a few signs that said "For Sale. . . For Sale." Now, in Italian, sale means salt. So she said, "Do they need such big houses full of sale?" She was puzzled. So we arrived in Chicago, and my father was waiting for us at the station. The first thing my mother said to my father was "Angelino, will you tell me why you need so much salt in America?" My father said, "What do you mean?" She said, "On the train we saw lots of signs that said sale, sale, sale." My father smiled and said, "Oh, that means they want to sell those houses, not that they are full with salt." My mother said, "Oh."

So we came here. We had a four-room house. We had beds, dishes, and a stove, but no carpeting. Our floors were bare boards. My father said, "There is no money to put on the floor to walk on. Scrub it and keep it clean." So we all struggled and worked to make a new life.

GOING TO SCHOOL IN AMERICA

I remember the first day at school was terrible. I was nine years old and dressed in my Italian clothes, which really were better than theirs, but the style was different, and to them I looked different. They laughed at me, and I used to cry. I couldn't understand what they were saying—but I knew they were laughing at me. Only God knew what they were saying to me.

OPERA ON SATURDAYS

My husband was always in love with music, as I was. We loved opera on Saturday when we were doing housework. During the week, the dust would lay wherever it was. We had to wash and iron. On Saturday was the plucking the chickens and cleaning the house. So we all had something to do. So, on the radio every Saturday, there was opera from New York. When the opera was on, nobody could talk. Nobody could talk, whether we like it or not. We had to talk only in the intermission of the opera. The children. . . they had to listen. Now that they got older, my children are in love with music. My children saw operas in Grant Park long ago. They're all in love with singing. They know every opera. They all love music—art and music. My favorite would be *Traviata*. I even named my daughter Violetta.